Museums &

Galleries

of

San Francisco &
the Bay Area

by kristine m. carber

Wide World Publishing/Tetra

Published by
WIDE WORLD PUBLISHING/TETRA
P.O. Box 476
San Carlos, CA 94070

1st Printing June 1996.

Printed in the United States of America

Library of Congress Cataloging-Publication Data
Carber, Kristine M.
 Museum & galleries of San Francisco & the Bay area /
by Kristine M. Carber.
 p. cm.
 Includes index.
 ISBN 1-884550-09-6 (alk. paper)
 1. Museums--California--San Francisco--Guidebooks.
2. Museums--California--San Francisco Bay Area--Guidebooks.
3. San Francisco (Calif.)--Guidebooks. 4. San Francisco Bay
Area (Calif.)--Guidebooks. I. Title. II. Title: Museums and
galleries of San Francisco and the Bay area.
AM13.S26C37 1996
069'. 09794'6--dc20 96-27772
 CIP

CONTENTS

Museums & Galleries of San Francisco

Museums & Galleries of the East Bay

CONTENTS

Museums & Galleries of Marin County

Museums & Galleries of the Peninsula & the South Bay

Museums & Galleries of San Francisco

San Francisco Museum of Modern Art
Center for the Arts at Yerba Buena Gardens
California Historical Society
Wells Fargo History Museum
Cartoon Art Museum
Circle Gallery
Ansel Adams Center for Photography
Vorpal Gallery
Pacific Heritage Museum
Chinese Historical Society of America
Chinese Cultural Center
San Francisco Performing Arts Library & Museum
Jewish Museum of San Francisco
Museum at Mission Dolores
Levi Strauss Museum
Galeria de La Raza
Exploratorium
Esprit Collection of Quilts
Museum of the City of San Francisco
National Maritime Museum
Octagon House
San Francisco Craft & Folk Art Museum
Mexican Museum
SF African American History & Cultural Society
Museo ItaloAmericano
Haas-Lilienthal House
San Francisco Art Institute
San Francisco Cable Car Museum
Presidio Museum
California Palace of the Legion of Honor
M.H. de Young Memorial Museum
Asian Art Museum
California Academy of Sciences
Conservatory of Flowers
Treasure Island Museum

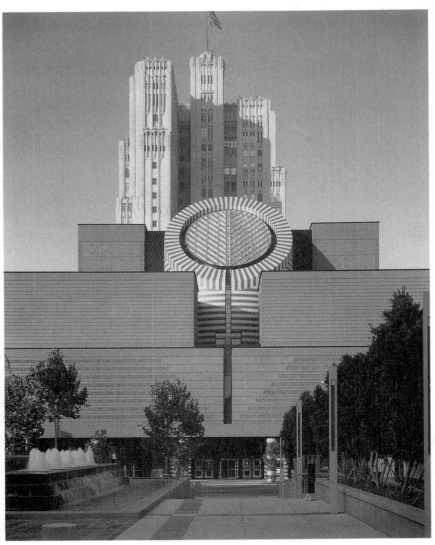

Exterior view of the San Francisco Museum of Modern Art.
Courtesy of San Francisco Museum of Modern Art. Photo by Richard Barnes.
©SFMOMA/Richard Barnes 1994.

SAN FRANCISCO MUSEUM OF MODERN ART

151 Third St. between Mission and Howard Streets

San Francisco

(415) 357-4000

Hours: daily 11am-6pm; Thurs 11am-9pm

Admission: $7 adults; $3.50 seniors and students; children 13 and under; half price every Thursday from 6-9pm; free first Tuesday of the month.

Without a doubt, the stunning 225,000 square-foot Museum of Modern Art is the best new public building in San Francisco since the early 1900s. Designed by Swiss architect Mario Botta, who worked for both Le Corbusier and modernist Louis Kahn before establishing his own firm, this architectural masterpiece is the largest new American art museum of the decade and the second largest single facility in the nation devoted to modern art. Botta incorporated his signature brick and stone construction, adding a zebra striped "periscope" tower surrounded by geometric, block-like forms.

Inside you'll find an elegant black and gray marble lobby, reminiscent of an Italian piazza. The atrium space opens onto two large workshop/studio spaces, a multiple-use event space, expanded bookstore and new cafe; the slanted rooftop skylight floods the area with daylight.

With more than 16,000 artworks represented, this museum truly has something for everyone. If contemporary art isn't your thing, there are galleries of classic modern art, photography, architecture and design.

On the second level is the popular standing exhibit, *From Matisse to Diebenkorn: Works from the Permanent Collection of Painting and Sculpture,* featuring more than two hundred works from 1900 - 1980. Artists Manuel Neri, Salvador Dali, Max Ernst and Jackson Pollock highlight the collection, which has some of the most important and influential work of this century. Major holdings include Matisse's vibrant painting of his wife, *Femme au chapeau* (1905), and Frida Kahlo's *Frida and Diego Rivera* (1931).

Several galleries are devoted to California art by Richard Diebenkorn, Wayne Thiebaud, Joan Brown, Robert Arneson (including his self-portrait *California Artist,* 1982) and others. The museum also has works by members of the New York School Mark Rothko, Franz Kline and Robert Motherwell.

Into a New Museum: Recent Gifts and Other Acquisitions of Contemporary Art has contemporary works by Warhol, Sigmar Polke, Willem de Kooning, Robert Ryman, Jeff Koons. A small gallery is devoted to Swiss-born Paul Klee.

On the third floor is the photography collection, with some 9,000 images dating from the 1840s and representing each of the major movements. The collection is organized chronologically and provides a survey of significant historical and national groupings, beginning with 19th century photographers Julia Margaret Cameron and Edweard Muybridge. Pictorialist works dating from the turn of the century feature images by Alfred

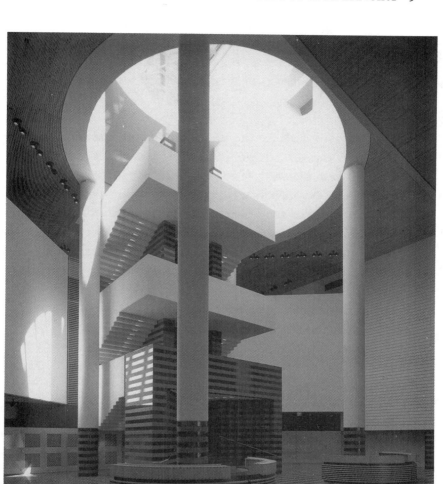

Interior view the San Francisco Museum of Modern Art with interior stairwell.
Photo courtesy of SFMOMA. ©SFMOMA/ Richard Barnes 1994.

Stieglitz, Clarence White and Alvin Langdon Coburn. Group f/64, a group of Bay Area photographers who helped promote photography as art, is represented by Edward Weston, Ansel

Adams and Imogen Cunningham. SFMOMA's permanent collection also preserves works in the documentary tradition, particularly those of Lewis Hine, Walker Evans and Dorothea Lange.

In the third-floor architecture and design gallery is an exhibition of armchairs and rockers promoting fifty years of experimentation in the form of sitting. The chairs are arranged as objects of beauty as well as a comfortable place to put your body. Paired with the Schindler chair is architect Frank Gehry's *Play Club Chair with Off Side Ottoman,* an updated basketweave armchair. A green and yellow stained wood rocker by architect Mark Mack is coupled with one designed by Charles and Ray Eames.

The fourth level has temporary exhibits and offices; traveling exhibitions are on the fifth floor.

Shop: One of the best museum shops in the city, the Museum Store carries a superb selection of gifts related to contemporary art and architecture. Exclusive to the store are paper products showcasing Klee, Matisse and Chagall, jewelry inspired by the building's design, and custom-made pottery with the MOMA inscription on back. The children's section has innovative games and toys. A sale nook discounts beautiful art books more than 50 percent.

Caffee Museo: A starkly modern cafe furnished with Botta-designed furniture and featuring innovative California cuisine. Specialties include homemade foccacia sandwiches and desserts.

CENTER FOR THE ARTS AT YERBA BUENA GARDENS

701 Mission St.
San Francisco
(415) 978-2700

Hours: Tu-Sun 11am-6pm; Thurs. 11am-8pm

Admission: $4 adults; $2 seniors and students; free the first Thursday of the month from 6-8pm

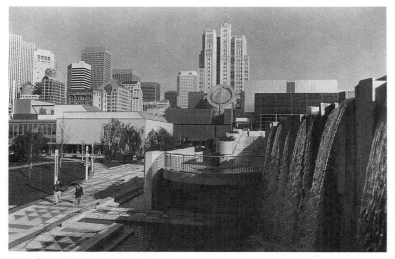

Yerba Buena Gardens with San Francisco Museum of Modern Art in background. Courtesy of San Francisco Convention & Visitors Bureau. Photo by Dawn Stranne.

Considered the heart of Yerba Buena Gardens, the $88 million Center for the Arts is a spectacular new visual and performing arts complex showcasing music, theatre, dance and visual art by contemporary Bay Area and international artists.

The two-story glass and stone gallery and forum was designed by award-winning Japanese architect Fumihiko Maki, reknowned

for his public buildings. Maki compares the building to an ocean liner, with its porthole-inspired windows, an observation deck and a flagpole modeled after a ship's mast.

Inside are three gallery spaces featuring revolving shows and exhibitions reflecting the Bay Area's multi-cultural population. The 755-seat Center for the Arts Theater designed by New York architect James Stewart Polshek is used for ballets, concerts and plays.

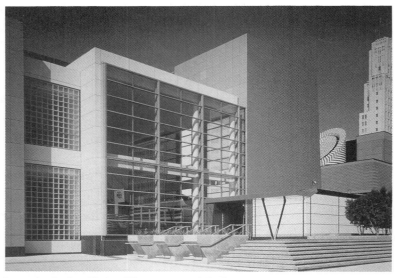

Center for the Arts Theater. Photo courtesy of the Center for the Arts.
Photo by Richard Barnes.

The building faces the five-acre Yerba Buena esplanade with terrace cafes, a two-story walk-through waterfall, a multi-language memorial to the Reverend Martin Luther King, Jr. and rolling lawn area.

Shop: Pottery and glassware by local and international artists as well as decorative arts and crafts from Africa and Indonesia.

CALIFORNIA
HISTORICAL SOCIETY

678 Mission St.

San Francisco

(415) 357-1848

Hours: Tu-Sat 11am-6pm

Admission : $3 adults; $1 students and seniors

After much hoopla the California Historical Society has joined the ranks of San Francisco cultural organizations moving to the rejuvenated South of Market area.

For more than 30 years the society was located in the historic Whittier Mansion in Pacific Heights before purchasing the 1922 Hundley Hardware building, which they renovated and seismically upgraded. Adolph Rosekrans, of the Spreckels sugar family, designed the renovation of the new building, which now features one main gallery and three small galleries.

The new space allows the society to showcase many of the artifacts it has collected over its 125-year history. In its holdings are more than 500,000 photographs, 150,000 manuscripts, and thousands of books, periodicals and fine art, including 600 watercolors, 350 oil paintings and 600 rare lithographs, chronicling the history of California from the 16th century to the present.

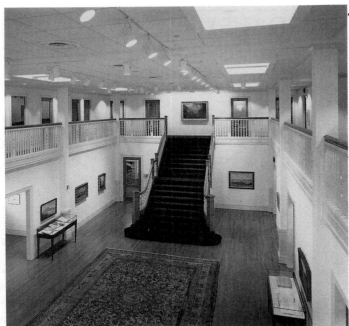

The inaugural show, *Happy Valley to South of the Slot; Transitions in a San Francisco Neighborhood,* celebrated South of Market with photographs, maps, drawings and other documents tracing the history of the area from early inhabitants to the South Park mansions of the 1800s and the transient hotel population of Skid Row.

Main exhibition gallery of the new headquarters of The California Historical Society. Photo courtesy of The California Historical Society. Photo by David Wakely.

Other exhibits will feature works from the San Francisco Art Institute's 125th anniversary celebration, and early California through the lenses of California photographers.

Shop: Operated by the Golden Gate National Recreation Area, this store offers an extensive selection of history books, photographs, lithographs and memorabilia.

WELLS FARGO HISTORY MUSEUM

420 Montgomery St.
San Francisco
(415) 396-2619

Hours: Mon-Fri 9am-5pm
Admission: free

Step back in time to the 19th century when passengers traveled by stagecoach and gold dust was weighed on large scales. At the Wells Fargo History Museum you'll find exhibits depicting life and banking from the time of the bank's founding in 1852 to the present.

The museum is housed on two floors of a downtown Wells Fargo branch. On the lobby level are displays of old strongboxes, tools, postal envelopes and original papers from Wells Fargo offices of a century ago. A restored Concord stagecoach is showcased in the window.

On the second floor you can sit inside a recreation stagecoach and listen to a narration taken from a passenger of an actual journey across the dusty plains. At one time these carriages carried as many as 18 people - nine inside and nine on top.

The company's stagecoach empire reached its peak between

1866 and 1869 when Wells Fargo controlled the overland mail and transportation in the western United States. A bronze sculpture of a Pony Express rider pays tribute to the year Wells Fargo operated the Pony Express between Sacramento and Salt Lake City.

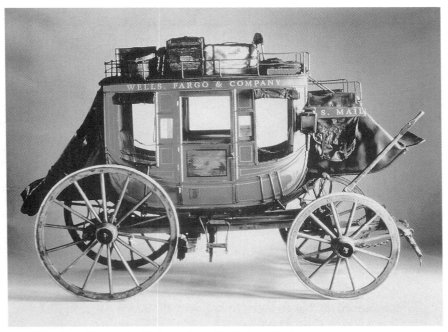

Wells Fargo Stagecoach. Photo courtesy of Wells Fargo Bank.

CARTOON ART MUSEUM
814 Mission St.
San Francisco
(415) CAR-TOON

Admission: $3.50 adults; $2.50 students and seniors; $1.50 children

Hours: Wed-Fri 11am-5pm; Sat 10am-5pm; Sun 1-5pm

This is a must stop for anyone who likes the comics. Founded in 1984, it is the only museum on the West Coast dedicated to cartoon art. Exhibits change regularly, featuring such favorites as Batman, Dick Tracy, Popeye, Brenda Starr and Little Orphan Annie among others.

Comics as an art form and entertainment have a rich history. The first comic strip, Outcult's *The Yellow Kid,* appeared in the *New York World* on May 5, 1895. On November 15, 1907, *The San Francisco Examiner* ran the first serialized comic strip, *Mutt and Jeff* by Bud Fisher. In recognition of the birth of the comic strip, the Cartoon Museum put together an exhibition highlighting some of the most memorable and classic comic strips of this country — *One Hundred Years of Cartoon Art.*

For several years, the museum floated among different corporate spaces until receiving an endowment from businessman Malcolm Whyte and Peanuts cartoonist Charles Schulz. In 1995, it

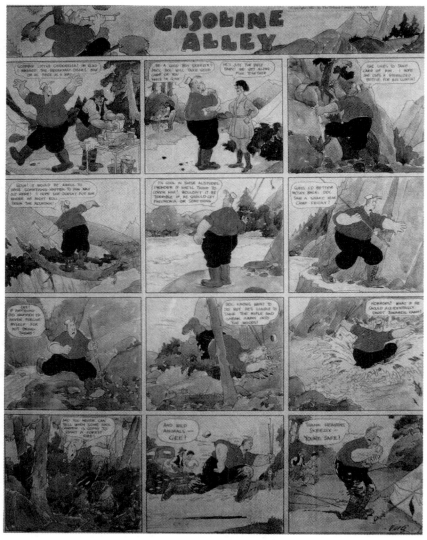

Gasoline Alley by Frank King. 1921. Photo courtesy of the Cartoon Museum.

moved to its present location in the historic Bulletin Building, where William Randolph Hearst published the Call Bulletin.

The Hearst Corporation promoted the comic strip from the early part of the century to the present.

In the main gallery you'll find rotating works from the permanent collection of more than 11,000 mainstream and alternative pieces from the late 1700s to the present. Themes range from 20th-century lifestyles to the twisted humor of Mad magazine.

Other highlights include rare Russian editorial cartoons from the '50s; a Krazy Kat watercolor and signed note by cartoonist George Herriman; Pogo strips; and sketches and storyboards from the Disney movie Fantasia. One of the main donors is pop singer Graham Nash, who provided more than 180 pages of original art from mainstream and underground comic books.

In addition to the main galleries, there is an interactive gallery with computers and CD-ROMs.

Shop: Mugs, t-shirts, posters and hard-to-find comics.

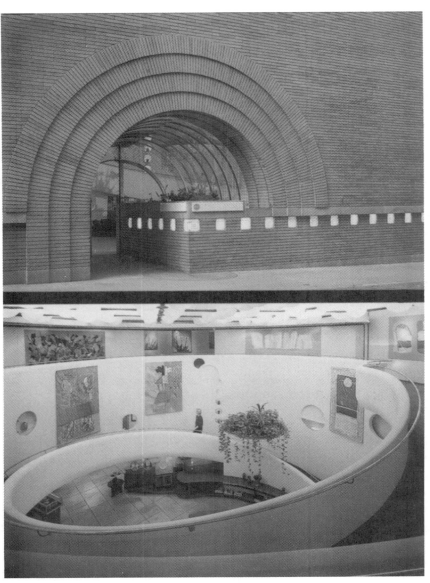

The Circle Gallery Building. Photo courtesy of the Circle Gallery. Photo by Jane Lidz.

CIRCLE GALLERY
140 Maiden Lane
San Francisco
(415) 989-2100

Hours: Mon-Sat 10am-6pm;Sun 12N-5pm
Admission: free

One of the architectural wonders of San Francisco, this building was first built in 1911 and was redesigned in 1949 by Frank Lloyd Wright for V.C. Morris. The plans were originally intended for the Guggenheim Museum in New York, but city officials found them too daring. Wright showed the blueprints to Morris who liked the futuristic design and asked the architect to use them for his new crystal and china shop. Wright ingeniously incorporated the round shape of the dishes and glasses throughout the interior, from the spiral ramp and sky-lighted ceiling to the curved walnut cabinets and tables.

V.C. Morris closed after several years and the building housed a number of retailers before the Circle Gallery took over the lease in 1983. Today the building is a beautiful setting for the gallery's wide range of contemporary art.

ANSEL ADAMS CENTER FOR PHOTOGRAPHY

250 Fourth St.

San Francisco

(415) 495-7000

Hours: Tu-Sun 11am-5pm; first Thursday of the month 11am-8pm

Admission: $4 adults; $3 students: $2 seniors and youth (13-17); children under 12 free

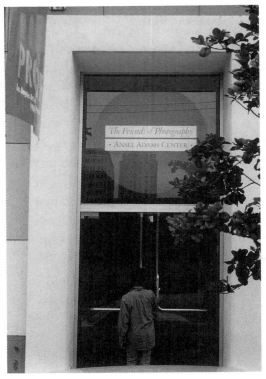

Entrance to the Ansel Adams Center for Photography. Photo courtesy of The Friends of Photography, San Francisco.

This museum is the only one in Northern California dedicated entirely to photography. It is operated by Friends of Photography, a group which was founded in Ansel Adams' Carmel living room in 1967 to promote the development of creative photography through shows, publications and seminars. The Center opened south of Market in 1989 as the first arts organization in the Yerba Buena cultural district.

There are five galleries, one of which is dedicated to Adams' legacy. A recent show featured the photographer's Kodak camera, a picture of Adams on the cover of Time magazine, and original photographs of *China Beach* and *Yosemite Monolith, the Face of Half Dome* .

In 1979, Adams was commissioned by the National Portrait Gallery to take the official Presidential Portrait. This was the first time in U.S. history that the official executive portraits were done by a photographer, not a painter. Four copies were made: one is in the National Portrait Gallery; one was given to President Carter; one is in the Polaroid Collection and one was given to Adams, now part of the Center's permanent collection.

The remaining four galleries rotate exhibits which have included works by acclaimed photographer Annie Liebovitz, Japanese Landscape Photography and *Posing for the Camera: Backdrops, Props and Presentation.*

Shop: One of the few bookstores in the nation specializing in photography and the only such store in the Bay Area. Besides matted prints and photo postcards, there's a large selection of anthologies, essays, exhibition catalogs and limited edition books. Photographers represented include Nan Goldin, Ruth Bernhard, Edward Weston, Dorothea Lange, and Walker Evans. This is also one of the few places in the world selling *Nouvelle Histoire de la Photographiers.*

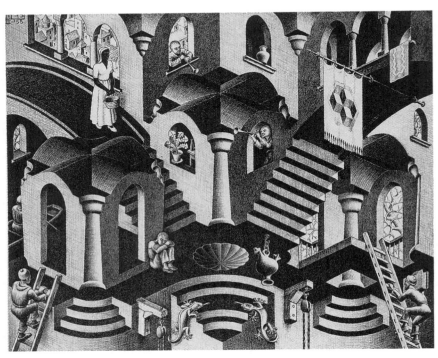

Concave & Convex by M.C. Escher, lithograph 1955.
Photo courtesy of the Vorpal Gallery.

VORPAL GALLERY

393 Grove St.

San Francisco

(415) 397-9200

Hours: Tu-Sat 11am-6pm

Admission: free

Once an auto parts warehouse, this 60,000 square-foot space was restored in the early '70s with white brick walls, hardwood floors and high beam ceilings to house the Vorpal Gallery.

The Vorpal was originally founded in North Beach in 1962 and made its mark in the art world as the first United States gallery to feature a major retrospective of M. C. Escher's work. Today they are the foremost dealer of Escher.

In the last decade, the gallery has expanded to promote contemporary painters and sculptors from over 30 countries. It is the exclusive dealer for Yozo Hamaguchi, the international master of colored mezzotint whose work can be found at the Museum of Modern Art in New York and the National Gallery in Washington D.C.

Other noteworthy artists represented include Japanese-American sculptor Kenneth Matsumoto, Jesse Allen and Mexican traditionalist painter Rudolfo Morales.

Besides contemporary art, the Vorpal has masterprints by Pablo Picasso, Francisco Goya, Winslow Homer, Rembrandt Van Rijn and Albrecht Dürer.

Moa, etching by Jesse Allen. Photo courtesy of the Vorpal Gallery.

PACIFIC HERITAGE MUSEUM
608 Commercial St.
San Francisco
(415) 362-4100

Hours: Mon-Fri 10am-4pm
Admission: free

This landmark building was originally built in 1875 as the U.S. Subtreasury Building on the site of the first local Branch Mint. The Bank of Canton purchased the building in 1970, and restored it as their San Francisco headquarters, opening the superb Pacific Heritage Museum in 1983.

Spread over three floors, the museum celebrates changing exhibits on the art and culture of the Pacific Rim. Themes range from Chinese antiquities and classical furniture to Thai ceremonial objects and Pacific aviation.

On permanent display is a historical exhibit documenting the history and significance of the Branch Mint and Subtreasury Buildings. In addition to architectural plans and photographs, there are bullion boxes, an old vault and a cart used to transport coins. One case has 40 years of silver dollars.

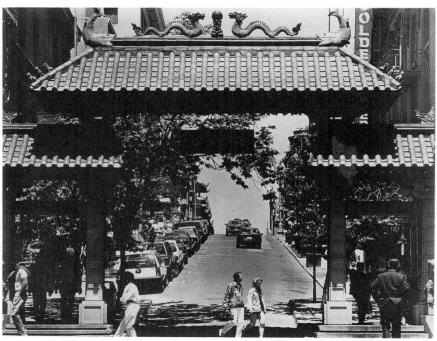

A gift from the Republic of China, the dragon-crested gate at Grant Avenue and Bush Street is the front door to San Francisco's Chinatown.
Photo by Kerrick James, courtesy of the San Francisco Convention and Visitors Bureau.

CHINESE HISTORICAL SOCIETY OF AMERICA

650 Commercial St.
San Francisco
(415) 391-1188
Hours: Tu and Fri 12noon-4pm
Admission: free

While Chinatown, the oldest neighborhood in San Francisco and the largest oriental community outside Asia, is a must-see, many visitors limit their exploration to the shops along Grant Avenue. Several museums tucked along the side streets are also worth exploring.

One is located in the headquarters of the Chinese Historical Society, founded in 1963 to preserve the history of the Chinese in North America. The museum is on the basement level, in a spacious room filled with antiques and artifacts of life growing up in Chinatown from the mid-1800s. Besides an 1880 Buddhist altar, you'll see a Chinese scale for weighing gold, clothing and slippers of 19th-century Chinese pioneers, a porcelain pillow and dishes.

In the center of the room is a 14-foot fishing sampan used in the Chinese shrimp camps before fishing nets were banned. At one time San Francisco shipped a million pounds of dried shrimp to Asia, in addition to supplying local markets.

Herb boxes, cutters and urns document the importance of herbs in Chinese medicine. There is a photograph of Li Po-tai (1817-1893), the most famous herb doctor in Chinatown whose patients included Mark Hopkins and Leland Stanford.

Other historical photographs trace the struggles of the Chinese in building a home in the West.

Shop: Books on Chinese America, Chinese vases, teacups, boxes, cards and baskets.

CHINESE CULTURAL CENTER
750 Kearny St.
San Francisco
(415) 986-1822

Hours: Tu-Sat 10am-4pm; Sun 12noon-4pm

Exhibits change regularly at this gallery-style museum located on the third floor of the Holiday Inn on Portsmouth Square. Shows relate to Chinese culture and art and range from contemporary interpretations of teapots to 20th century woodblock prints of Chinese New Year dieties and guardians. In the lobby is a fascinating display of Chinese musical instruments: a gong-like Luo, the most popular folk instrument, the Di (a bamboo flute), and the Biba, similar to a lute in appearance but sounding like a banjo.

The hotel itself overlooks Portsmouth Square, laid out in 1837 under Mexican rule and named for the U.S. warship *Portsmouth*. Benches are painted in the traditional good luck color red. The square is a popular gathering place for locals who play ma jong or practice tai chi. Chinese Heritage walks are held every Saturday at 2 pm, leaving from the museum. Cost: $15/adult, $3/children.

While there's no cafe at the Cultural Center, there are many good Chinese restaurants within a short walk. If you haven't tried dim sum - the delicious Chinese dumplings wrapped in a paper-thin dough - this is the place.

Shop: Antique plates, tea sets, jewelry and books.

*Sarah Bernhardt as Floria Tosca in **La Tosca**, the play by Sardou written especially for her in 1887, which she performed throughout her life.*
Photo courtesy of the San Francisco Performing Arts Library & Museum.

SAN FRANCISCO PERFORMING ARTS LIBRARY & MUSEUM

399 Grove St.
San Francisco 94102
(415) 255-4800
Hours: Tu-Fri 10am-5pm; Sat 12N-4pm
Donation

Ever since the mid-1800s, San Francisco has been a mecca for cultural activities, with more than 5,000 performances of opera between 1850 and 1906 alone. This rich heritage is preserved at the San Francisco Performing Arts Library & Museum, located in the heart of the performing arts center.

The Library was started by Russell Hartley, a ballet dancer whose passion for collecting paintings and books related to the performing arts became the foundation for PALM. Today the museum is funded through private donations and government grants and features rotating exhibits on everything from vaudeville to cabaret.

The archives are the second largest in the nation (only Lincoln Center has larger) and contain two million playbills, photographs, programs and scene and costume designs related to the performing arts. Celebrated collections include Isadora Duncan, Lew Christensen, the Chevron 'Standard Hour,' Lamplighters and Kirsten Flagstad. The Library has 7,000 books on all aspects of the arts and more than 2,000 video tapes of local performances. Newspaper clippings date to 1856.

THE JEWISH MUSEUM
OF SAN FRANCISCO

121 Steuart Street

San Francisco

(415) 543-8880

Hours: Sun. 11am-6pm; Mon-Wed 12noon-6pm; Thurs 12noon-8pm.

Admission: $3 adults; $1.50 seniors, students; free for children under 12; free the first Monday of the month.

In the 12 years since it was founded The Jewish Museum has earned a reputation for thought-provoking exhibitions designed to educate the public about Jewish history, traditions and values. Examples of these exhibits include *Art and the Rosenberg Era*, an in-depth look at the McCarthy era, and *Bridges & Boundaries: African Americans and American Jews.*.

One of the most innovative shows was *Light Interpretations: A Hanukah Menorah Invitational* celebrating original Hanukah lamps crafted by 126 Jewish and non-Jewish artists, architects and designers. Participants included Richard Meier, Stanley Saitowitz, Dale Chihuly, Fletcher Benton, Tom Holland, and Viola Frey. Such diverse interpretations ranged from "Maccabee Moose Menorah," a whimsical moose-like creature made of recycled wood and circuit boards to a stunning red and black lily-shaped menorah by glass designer Dale Chihuly.

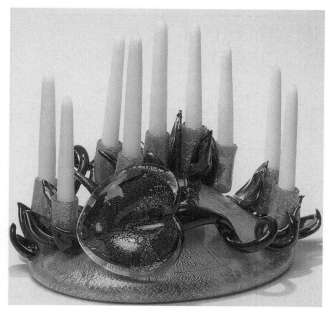

Red & Gold Menorah Venetian with Black Lily. Dale Chihuly in collaboration with Lino Tagliapietra. 1995. Glass. 8.5"hx16"wx13"d. Photo by Phil Hofstetter.
From Light Interpretation: A Hanukah Menorah Invitational. Exhibit was on display Nov.12-Dec.25, 1995. Photo courtesy of the Jewish Museum of San Francisco.

The museum also attracts world-acclaimed art. *Fifty Treasures/Fifty Stories* featured paintings and drawings from the Israel Museum in Jerusalem never before seen in the United States including works by Henri Matisse, Marc Chagall, and Paul Klee. The museum was the only West Coast venue for *From the Ends of the Earth: Judaic Treasures of the Library of Congress* , and the only U.S. venue for *Stones of Faith, Stones of Peace,* commemorating the 3,000th birthday of the city of Jerusalem.

In 1998, The Jewish Museum will relocate to the historic Jessie Street Substation building in Yerba Buena Gardens.

Shop: Books on Judism and Hebrew, jewelry, glass platters and contemporary menorahs as well as items related to current exhibits.

Cafe: No cafe, but many popular restaurants are within walking distance including One Market, Harry Denton's Bar & Grill and Bistro Roti.

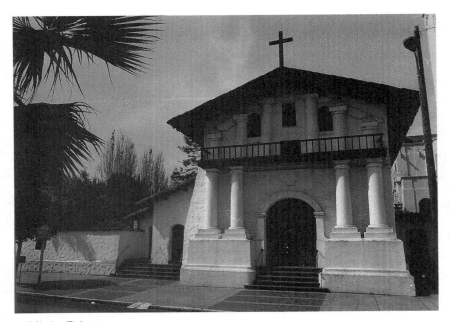

Mission Dolores

MUSEUM AT MISSION DOLORES

Dolores St. at 16th Street

San Francisco

(415) 621-8203

Hours: Daily 9am-4pm

Donation

Mission San Francisco de Asis is one of the great historical treasures of the Bay Area. It was completed in 1791 and is the sixth of the 21 missions, and the oldest building in San Francisco. Though its official name is Mision San Francisco de Asis, after Saint Francis of Assisi, it is more commonly known as Mission Dolores.

Before entering, take a moment to appreciate the amazing facade. It took more than thirty-six thousand adobe bricks to construct the mission, which has four-foot thick walls and a high vaulted ceiling. The parish church was built in 1876, but collapsed during the 1906 earthquake and was rebuilt in 1913. The facade was remodeled again in the '20s.

Inside you'll find a gilded altar and many old paintings and statues including a wood carving of Mater Dolorosa, Our Lady of Sorrows. A carved coat of arms has the papal insignia. The chapel ceiling is painted to replicate original Indian designs of

Costanoan baskets. It still has the original timbers, which until 1918 were fastened together with rawhide thongs. Three bronze bells hanging in their original nooks were brought from Mexico to honor different saints.

In 1976, a classroom was converted into a small museum to display salvaged mementos and artifacts, some of which were gifts from Father Junipero Serra. Especially significant are a baptismal register dating to 1776, lithographs of the California Missions and the ornate tabernacle from the Philippines. A small cutaway shows the original adobe construction. The cement stucco coating was later applied to preserve the building.

Outside is the oldest cemetery in the city, with more than 5,000 Spanish, Mexican, Costanoans and Yankees buried here. Many of the tombstones date to the Gold Rush era. One of the oldest is that of the first Mexican governor of California, Luis Arguello, who died in 1830.

The location of the grave was based on status. Elaborate marble obelisks of prominent residents are near the front, while unmarked tombs are in back. Burial next to the wall of the church was reserved for priests and governors.

LEVI STRAUSS MUSEUM

250 Valencia St.
San Francisco
(415) 565-9159

Hours: Tues. and Wed. by appointment
Admission: free

Marilyn Monroe loved them; Clark Gable and Lucy and Desi Arnez, too. Marlon Brando wore a pair of 501s in "Wild Ones" and the craze began. Since the 1950s, nothing has been more of an All American symbol than the denim jean, created by Bavarian immigrant Levi Strauss in 1853.

During the Gold Rush, Strauss operated a dry goods store, servicing miners, farmers and mechanics. When customers complained about the lack of durable clothes, he turned sailcloth into waist-high overalls. A short time later, Strauss and tailor Jacob W. Davis added copper rivets on the pocket corners and in the crotch to guarantee a garment that would not rip. In 1886, a patch showing two horses trying to pull apart a pair of Levi's became the company's logo. The jean's reputation for durability has lasted more than a hundred years.

The tour starts with a lively ten-minute video covering two decades of Levi commercials. A one-hour guided walking tour takes you through the oldest factory in existence, where you can still see workers making the garments. Inside the small museum you'll find old photographs and memorabilia chronicling the history of Levis. There's a denim suit custom designed for Bing Crosby, and a pair of gaudy jeans which won the employee design contest, *Jazz Up Your Jeans*, in 1991.

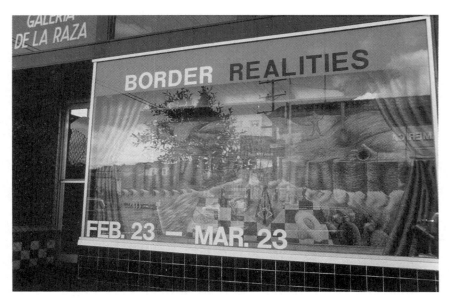

Galeria de la Raza. Photo courtesy of Galeria de la Raza.

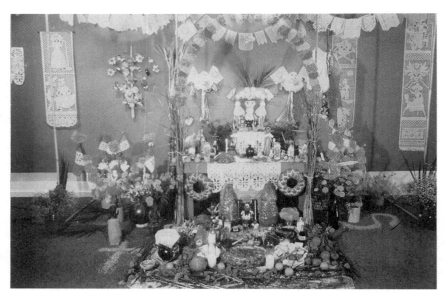

*Galeria de la Raza. **Dia de los Muertos** (Day of the Dead altar).*
Photo courtesy of Galeria de la Raza.

GALERIA DE LA RAZA

2857 24th St.
San Francisco
(415) 826-8009

Hours: Tu-Sat 12N-6pm
Admission: free

Celebrating its 26th year, Galeria de la Raza was established by a group of local artists in 1970 to exhibit and promote the work of Chicanos and Latinos. It was the first Mexican-American museum in the nation. Co-founder Peter Rodriquez went on to establish the Mexican Museum at Fort Mason.

The gallery gave early support to a number of local artists who have since achieved international recognition. Early exhibitions were also instrumental in bringing the work of unrecognized artists to the attention of Bay Area audiences. An exhibition devoted to the work of Frida Kahlo is credited with a revival of interest in the artist's life. Other renowned exhibits featured the work of Mexican muralists Diego Rivera, Jose Orozco and David Siqueiros.

The Galeria de la Raza has become one of the most respected of its kind in the nation and has served as a model for similar community-based organizations.

Shop: Studio 24 sells folk art, posters, textiles and pottery.

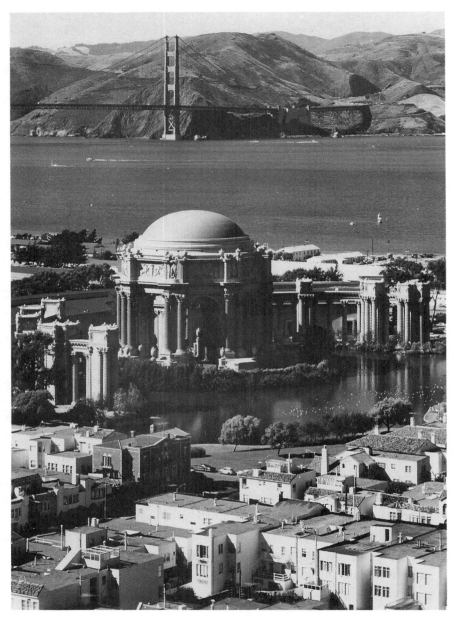

The Palace of Fine Arts. Courtesy of the San Francisco Convention Visitors Bureau.

EXPLORATORIUM

Palace of Fine Arts

3601 Lyon St. at Marina Boulevard

San Francisco

(415) 561-0360

Hours: Tu-Sun 10am-5pm; Wed. 10am-9:30pm; 10am-6pm daily from Memorial Day through Labor Day.

Admission: $9 adults; $7 seniors and students; $5 people with disabillites and youth (6-17); $2.50 children (3-5); children under 3 free.

Some people call it a mad scientist's playpen. Some call it infotainment. Whatever you call it, the Exploratorium is an intriguing showcase of quirky, clanking exhibits designed to teach you about the world and how your senses work.

Even if you never liked science, you'll find this place fascinating.

Masterminded by physicist Dr. Frank Oppenheimer, who wanted a place to teach natural phenomena through innovative hands-on exhibits, there are more than 650 displays exploring how we see hear, smell, and feel; in general, how we experience the world around us.

Exhibits are divided into thirteen categories: light, color, sound music, motion, animal behavior, heat and temperature, language, patterns, hearing, touch, vision, waves and resonance, and weather.

You can bend light, touch a tornado or move a 400-pound pendulum with a tiny magnet.

Explainers are stationed throughout the large, warehouse-like space to tell you the principle behind each display. One of the most popular is the pitch-black crawl-through Tactile Dome with chambers of different texture. An on-line World Wide Web system allows you to explore science activities on the Net.

The Exploratorium is housed in the spectacular Palace of Fine Arts, designed in 1915 by architect Bernard Maybeck for the Panama Pacific International Exposition. The structure was intended to last only a few years and began to decay over time. Private contributions and state funds enabled the city to restore the building. The massive rotunda and colonnade was demolished and rebuilt and the Exploratorium opened in 1969.

Shop: Considered one of the best in the city, the shop has dozens of innovative games, toys and books on nature and science.

Cafe: Snacks and meals are available.

ESPRIT COLLECTION OF QUILTS

900 Minnesota Street

San Francisco

(415) 550-3734

Hours: Weekdays by appointment

Admission: free

Since 1971, the ESPRIT headquarters has been a showcase for their world-renowned collection of quilts. In 1976, the building burned and the interior was rebuilt as a quilt museum, with special lighting and walls designed to hold the thirty to forty quilts on display at any time. The collection includes a cross section of American quilt making between 1860 and 1940. The emphasis is on conventional quilts with original or variations on traditional designs. Intricate craftwork can include shamrock shapes, botanical motifs, and interpretations of Log Cabin and Wagon Wheel designs. All tell a story of the women who made them.

One of the many sights available at The Cannery. On the far right is PIER 39. Alcatraz Island is in the background. Photo is by Jeff Murphy, courtesy of the San Francisco Convention and Visitors Bureau.

MUSEUM OF THE CITY OF SAN FRANCISCO

2801 Leavenworth St., Third floor

San Francisco

(415) 928-0289

Hours: Wed-Sun 10am-4pm

Admission: free

Tucked in a corner of the Cannery, this five-year-old museum is filled with mementos from the city's founding to present. Rotating exhibits feature the Spanish influence, the Gold Rush and natural disasters, with special emphasis on the earthquake and fire of 1906. Highlights include an 1888 carousel horse from Golden Gate Park, a miniature model of the Cliff House when it was first constructed in the 1860s, and vintage theater and motion picture projectors of the last century. On Saturdays there's a talk on "The Life Story of San Francisco," great events and characters that shaped the city.

Mayor Willie Brown recently approved $100,000 in public funding which will enable the museum to expand from 2,000 square feet to 8,000 square feet, and allow it to display more of its collection of local artifacts. The museum will move to a Civic Center location when the reconstruction of City Hall is complete.

Shop: Small selection of books, t-shirts and gift items.

NATIONAL MARITIME MUSEUM

San Francisco Maritime National Historic Park
Foot of Polk Street
San Francisco
(415) 556-3002

Hours: daily 10am-5pm
Admission: free

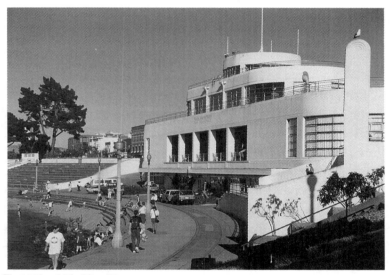

The National Maritime Museum.

Housed in an Art Deco building that was once a bath house, restaurant and jazz club, this seafaring museum features ship-scale models, large relics and colorful figureheads including a carved replica of Davy Crockett. The building was constructed as part of the Works Project Administration (WPA) and completed in 1939. The murals, sculptures and terrazzo marble floors were done by prominent artists and designers of the time.

Immediately inside the door you'll find a mammoth anchor from an 1812 ship and many ship-scale models, including one of Jack London's ill-fated *Snark*. Other rooms focus on West Coast whaling, bay yachting and the California Gold Rush. The Steamship Room traces the evolution of steam technology.

<p align="center">* * *</p>

<p align="center">**HYDE STREET PIER**
2905 Hyde Street
Hours: daily 9:30am-4:30pm</p>

Down the street from the Maritime Museum is the **Hyde Street Pier,** built to serve ferry traffic before the completion of the Golden Gate Bridge, and now home to a fleet of **Historic Ships.** Visitors can explore the **Eureka,** a sidewheel ferry built in 1890 and the world's largest passenger ferry in her day, **C.A. Thayer,** one of two surviving schooners from a fleet of 900 used to carry lumber from the Pacific Northwest, **Alma,** the last San Francisco Bay scow schooner still afloat and once carrying bulk cargo, the **Balclutha,** a square-rigged Cape Horn sailing vessel launched in 1886 in Scotland, and **Eppleton Hall,** built in England in 1914 and reminiscent of the paddle tugs that towed ships into the Bay during the Gold Rush.

OCTAGON HOUSE

2645 Gough St. at Union Street
San Francisco
(415) 441-7512

Hours: noon to 3:00pm on the second Sunday and the second and fourth Thursdays of each month except January and holidays.
Donation

One of San Francisco's best kept secrets is the Octagon House, built in 1861 by miller William C. McElroy and one of only two such houses remaining in the city.

McElroy read that the octagon shape promotes better health because it gives each room maximum sunlight. He designed the house to incorporate six double windows and two doors in the eight walls of the downstairs and eight double windows upstairs. This assured that sunlight was always shining into one of the rooms.

A small central room on top of the roof called a *cupola* has eight more windows to bring fresh air and sunshine into the center of the house. The windows can be opened for a cooling effect. From here the McElroys could see the ships sailing in and out of the Golden Gate.

The family owned the house for forty years. The property had a

succession of owners before Pacific Gas and Electric purchased it in 1924, selling it to the Colonial Dames of America in 1952 for one dollar in exchange for restoring and moving it across the street from its present location. The house was declared an Historical Landmark in 1968, and placed in the National Register of Historic Places in 1972. Today it is furnished with authentic furniture and decorative arts from the Colonial and Federal periods.

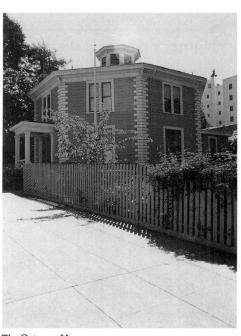

The oldest piece on display is a c.1700 walnut William and Mary dressing table in the entry. Across the hall is a superb c. 1790 cherry tall-case clock with birdseye maple insets and brass finials; a corner cupboard is filled with stunning Chinese export porcelain taken as a war prize from a British frigate in 1812.

The Octagon House.

Upstairs you'll find the "Signers Room," showcasing the signatures of all but two of the signers of the Declaration of Independence. The bedroom has an 1800 half-tester *Press Bed* which was the inspiration behind today's Murphy bed. Other period furnishings include an 18th century card table, rare books and an 1820 settee.

SAN FRANCISCO CRAFT & FOLK ART MUSEUM

Fort Mason Center, Bldg. A

Buchanan St. and Marina Blvd., San Francisco

(415) 775-0990

Hours: Tues to Sun 11am - 5 pm; Sat 10am-5pm

Admission: $1 adults; $.50 youth and seniors; free Saturday 10am-12N and the first Wednesday of the month 11am-7pm.

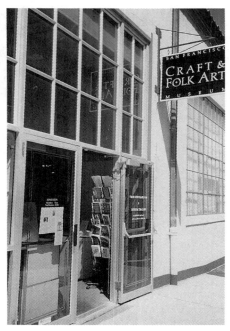

The San Francisco Craft & Folk Art Museum. Photo courtesy of the SF Craft & Folk Art Museum

Since its founding in 1983, this museum has presented dozens of witty and innovative shows on contemporary and traditional American and international art, from Bay Area Violin and Bow Makers to folk art of the Soviet Union. One project, *Riches From Rags*, showcased elegant rural clothing recycled from urban discards in turn-of-the-century Japan. *Have Birdcage, Hat Box and Silk Case; Will Travel* featured late 19th and early 20th century household containers as art.

The museum gained international recognition after a major exhibit of Chinese classical furniture brought together by leading scholars from Asia and Europe and collectors from all over the world. Since then exhibitions have traveled to the Smithsonian, Field Museum in Chicago and American Craft Museum in New York.

Shop: Ethnic arts and crafts from around the world: handwoven baskets, mouthblown glass, sculptures, pottery and handsewn clothes and quilts.

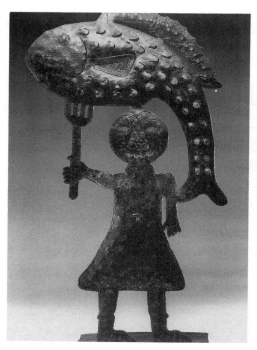

Cafe: No cafe, but neighboring Greens restaurant has superb vegetarian food in an airy setting overlooking the water.

From the Heart of Ogun: Steel Drum Sculptures of Haiti.
Spirit of the Sea. Jonas Pascal. 1991.
Photo courtesy of the SF Craft & Folk Art Museum

MEXICAN MUSEUM

Fort Mason, Bldg. D

San Francisco

(415) 441-0404

Hours: Wed-Sun 12N to 5pm; Wed. 12N - 7pm; free on the first Wednesday of each month

Admission: $3 adults; $2 seniors and students; children under 10 free

Maternidad 1972 by Francisco Zuniga.
Bronze. Gift of Dr. & Mrs. Bernard Horn Collection of the
Mexican Museum.
Courtesy of the Mexican Museum.

Founded in 1975 by Hispanic artist Peter Rodriguez, this intriguing10,000 square-foot museum is the first in America dedicated to collecting, conserving and exhibiting Mexicano and Latino art.

More than 9,000 items make up the permanent collection, which falls into five categories: pre-Conquest, colonial, contemporary Mexican, Mexican-American/ Chicano, and folk art. Included in this are works by the great

muralists David Alfaro Siqueiros and Jose Orozco. Exhibits have featured Frida Kahlo, Diego Rivera, Rufino Tamayo, Leonora Carrington and the Rockefeller Collection of Mexican Folk Art. The museum also showcases emerging artists; one of the first was Rupert Garcia, now internationally acclaimed and a professor of art at San Jose State University. In 1996, the museum mounted the first solo exhibition in the United States devoted to Nahum B. Zenil, a contemporary of Frida Kahlo who also explores issues of nationalism, the family, religion and Mexican culture.

Santiaguero Mask. Puebla 20th Century.
Carved wood, paint, cloth, ribbon collar.
From the permanent collection of the Mexican
Museum. Courtesy of the Mexican Museum.

Though now housed in a remodeled military base, the museum is scheduled to open in 1998 in a 50,000-square foot building on Mission Street across from Yerba Buena Gardens. In addition to galleries and a gift store, the spectacular new space will have a 130-seat theater, classrooms, a library and administrative offices.

Shop: *La Tienda* stocks a magnificent collection of handicrafts and traditional folk art from Mexico and Latin America. Besides pottery and ceramics, there are wooden masks, tin mirrors and handmade jewelry. The excellent selection of books includes guides to Hispanic art and architecture as well as biographies of legendary figures. A special annex opens to celebrate the Day of the Dead.

From the collection of Photographs of African American Soldiers.
Courtesy of the African American Historical and Cultural Society.

SAN FRANCISCO AFRICAN AMERICAN HISTORICAL & CULTURAL SOCIETY

Fort Mason Center, Bldg. C

Buchanan Street and Marina Boulevard

San Francisco

(415) 441-0640

Hours: Wed-Sun 12N-5pm

Admission: $1 adults; $.75 seniors; $.50 youth (1-18); free the first Wednesday of the month 11am-7pm.

Preserving the history and culture of the African American people is the focus of the San Francisco African American Historical and Cultural Society, founded in 1955 and featuring new and master artists from all over the world. Recent shows have included the last few years of Martin Luther King and printmakers Henry O. Tanner, Grafton Tyler Brown and Ed Clark. The Howard Thurman Listening Room has his taped lectures, as well as musical compositions by local, national and international African American artists.

Shop: African American and African art and crafts including soapstone sculptures, Kuba boxes, handsewn cotton hot pads, aprons and placemat sets.

*Tavola della Memoria by Arnaldo Pomodoro, 1961. Bronze. 220x100cm.
Photo courtesy of Museo ItaloAmericano.*

MUSEO ITALOAMERICANO

Fort Mason, Building C
San Francisco
(415) 673-2200

Hours: Wed-Sun 12N-5 pm
Admission: $2 adults: $1 seniors and students; free
on the first Wednesday of the month 12N-7pm

This delightful museum was founded in 1978 by Giulian Nardelli Haight to promote Italian culture in California and to create a greater awareness of the role Italian-Americans have played in the arts. First located in a space above Malvina's Coffee House in North Beach, the museum moved to historic Casa Fugazi before its present home at Fort Mason.

Exhibits rotate regularly with such diverse themes as *Jewels of Wheat: The History and Tradition of Pasta* to *The Italian Motorcycle as Sculpture*. A small permanent collection includes works by prominent and contemporary painters Nino Longobardi, Francesco Clemente, Mimmo Paladino and Tom Marioni. Especially significant are the bronze sculpture by noted Milanese sculptor Arnaldo Pomodoro and Beniamino Bufano's large bronze *Elefante*, a rotund elephant on long-term loan.

Besides art, the museum offers classes on Italian art, language, history, culture and life.

Shop: A treasure trove of Italian cooking paraphernalia, books, jewelry and ceramics. The Museo Cook Book is a compilation of more than 100 Italian recipes.

By Emilio Tadini. From the permanent collection.
Photo courtesy of Museo ItaloAmericano.

HAAS -LILIENTHAL HOUSE

2007 Franklin St.

San Francisco

(415) 441-3000

Hours: Wed 12noon -3:15 pm (last tour); Sun
11am-4: 15pm (last tour

Admission: $5 adults; $3 seniors and
children under 12

Built in 1886 by wholesale grocer William Haas at a cost of
$18,500, this elegant Queen Anne-style Victorian is an excellent
example of residential designs of the late 1880s. It is made of
redwood and includes many features typical of the ornate Queen
Anne style, most notably the round corner tower and "witch's
cap."

The plan of the interior retains its original Victorian form,
although the large formal rooms of the main floor - front
parlor, second parlor and dining room - underwent remodeling
at the turn of the century. Many furnishings are original to the
house and span the life of the Haas-Lilienthal family through
the mid-20th century.

The house is now home to The Foundation for San Francisco's
Architectural Heritage, founded in 1971 and dedicated to pre-
serving San Francisco's architecturally and historically significant

buildings. Heritage owns the property and trains the guides who lead tours of the house and a walking tour of its Pacific Heights neighborhood every Sunday at 12:30.

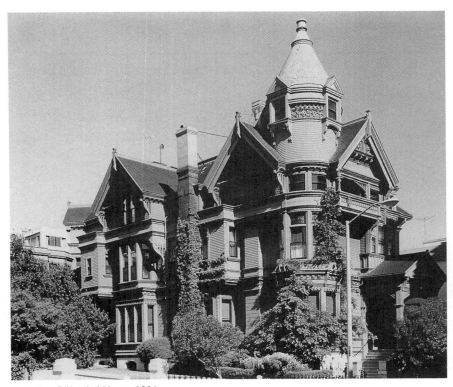

Haas-Lilienthal House, 1886.
Photo courtesy of San Francisco Heritage.

SAN FRANCISCO ART INSTITUTE

800 Chestnut St.

San Francisco

(415) 771-7020

Hours: Tu-Sat. 10am-5pm

Admission: free

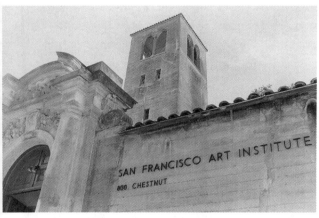

San Francisco Art Institute. Photo by Philip Blake, courtesy of the San Francisco Art Institute.

Founded in 1871 by a group of artists and writers, this magnificent Spanish Colonial-style complex with its narrow corridors and arched passageways is the oldest cultural institution in the West and one of the most respected in the local art community.

Tucked back on a quiet Russian Hill street, the Institute was designed in 1926 by famed San Francisco architect Arthur Brown, who also designed Coit Tower, City Hall and the War Memorial Opera House. Besides art studios, there are a library, offices and galleries clustered around a central courtyard and tower.

The school has an intriguing history. Following World War II,

it was the heart of abstract expressionism, attracting artists like Mark Rothko, Hassel Smith and Frank Lobdell. In 1946, Ansel Adams created the nation's first fine art photography department. Imogen Cunningham, Dorothea Lange and Edward Weston were instructors here. Annie Leibovitz was a student. In the 1950s, the school was the center for leading figurative artists represented by Richard Diebenkorn, Joan Brown and Elmer Bischoff.

Though art is showcased throughout the grounds, there are two main galleries: the Walter/McBean Gallery and the Diego Rivera Gallery. The Rivera Gallery has one of only three murals by the artist in the Bay Area. The mammoth fresco was commissioned in 1931 and depicts a cross-section of an American city.

Adjoining the building is a 99-foot Italian Renaissance tower housing the archives and used in the Hitchcock thriller, *The Birds*. It is reportedly haunted by a ghost who turns lights and equipment on and off.

Many legendary figures are linked to the school, most notably Janis Joplin, who worked in the cafe, former activist Angela Davis, who taught aesthetics, and Frank Lloyd Wright and Marcel Duchamp, both of whom attended a Western Roundtable on Art hosted by the school.

Shop: Discounted art supplies.

Cafe: Coffee drinks and pastries are served in the cafe, where there's a panoramic view of Alcatraz, the Bay and Golden Gate Bridge. The Institute is around the corner from Lombard Street, the crookedest street in the world. Levi Strauss Plaza, designed by landscape architect Lawrence Halprin, is reached via the Filbert Street steps and a pleasant place to enjoy a cappucino or lunch.

SAN FRANCISCO CABLE CAR MUSEUM

Washington & Mason Streets.

San Francisco

(415) 474-1887

Hours: Daily 10am-6pm April through October;
10am-5pm November through March

Admission: free

Housed in the actual barn where cable cars are stored, this historic museum building was constructed in 1887 and then rebuilt after the 1906 earthquake.

Old photos and memorabilia tell the story of the cable car, which was invented in 1873 by Scotsman Andrew S. Hallidie, who saw a horse stumble and die while carrying goods up a steep hill. Hallidie wanted a way other than by horse of transporting goods. He proposed a grip system, using powerful cables strong enough to pull the cars up the hills. The city laughed at his plan, calling it "Hallidie's folly," but in 1872, he was awarded a franchise to build and operate the world's first cable railway up the Clay Street hill. By 1880, eight lines were operating on 112 miles of track, carrying residents to all parts of the city including Nob Hill. By 1890, over 600 cable cars were in service.

The cable car is the only moving National Historic Landmark in

the United States. There are two types of cars still in operation: a double-ended that can be driven from either end, and a single end that must by turned around on a turntable. There are examples of both on the second floor where the cars are stored. The original paint scheme, and iron and brass detailing have

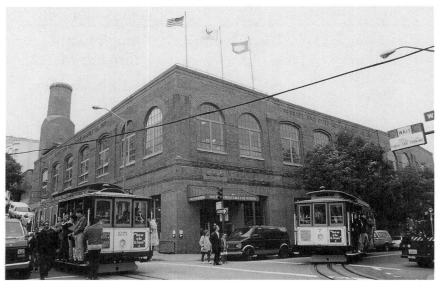

The San Francisco Cable Car Museum. Courtesy of the San Francisco Cable Car Museum.

been retained so the cars look the same as they did in the 1880s. The lower level has a viewing platform for watching the mammoth gear cables and pulleys that power the cars.

The historic barn-museum was remodeled in 1982 as part of a $62 million Cable Car System Rehabilitation Program. The brick facade was preserved, but the interior was completely rebuilt. The cars were refurbished and the system itself was reconstructed to make it safer.

Shop: Cable car postcards, key chains and other memorabilia.

PRESIDIO MUSEUM

Lincoln Blvd. and Funston Avenue
San Francisco
(415) 561-4331

Hours: Wed-Sun 10am-4 pm
Admission: free

Built as the Old Station Hospital in 1857, this museum focuses on the role of the military in the development of San Francisco since 1776. It is the oldest surviving structure in the Presidio.

The museum is divided into sections which cover the Spanish and Mexican eras, America's wars from the Civil War onward, the 1915 Panama Pacific Exposition, and the 1906 earthquake. Outside are two restored "earthquake cottages," one furnished as it would have been in 1906. Thousands of these temporary buildings were constructed for the homeless; only about 40 survive.

If time permits, drive around the spectacular park-like grounds, which were the headquarters of the United States Sixth Army until military cutbacks closed the base. The site was bare of vegetation when the Spanish first settled here in the 1700s. The eucalyptus and Monterey pines were planted by the Army in the 1890s.

Presidio grounds. Photo courtesy of U.S. Department of Interior, National Park Service, Golden Gate National Recreation Area.

At the Presidio Information Center in Bldg. 102 you can pick up maps, brochures and a quarterly calendar listing walks, talks and special events (415) 561-4311.

Shop: Two shops: one at the museum and one at the information center, both carrying books, t-shirts, flags and other memorabilia.

CALIFORNIA PALACE OF THE LEGION OF HONOR

Lincoln Park, 34th Avenue and Clement Street

San Francisco

(415) 750-3600

Hours: Tu-Sun 10am-4:45pm; 10am-8:45 pm the first Saturday of the month

Admission: $6 adults; $4 seniors:$3 youth (12-17); free the second Wednesday of the month.

After three years and a $37 million renovation, this stunning San Francisco landmark has reopened with a beautiful facelift and new interior, nearly twice the size of its former space.

Perched atop a hill in Lincoln Park with a panoramic view of the city and Pacific Ocean, the museum is one of the most magnificent in the country. It was built in 1924 and is home to more than 4,000 years of art from 2,500 B.C. through the 20th century. Its permanent collection includes eighteenth and nineteenth century Impressionist works by Monet, Renoir and Degas, decorative arts and tapestries. The Achenbach Foundation for Graphic Arts houses more than 100,000 works of art on paper, the largest of its kind in the West.

The building was designed by San Francisco architect George Applegarth and financed by sugar magnate Adolph Spreckels and his wife Alma. Applegarth trained at the Ecole des Beaux Arts in Paris and was inspired by the 18th century Hotel de

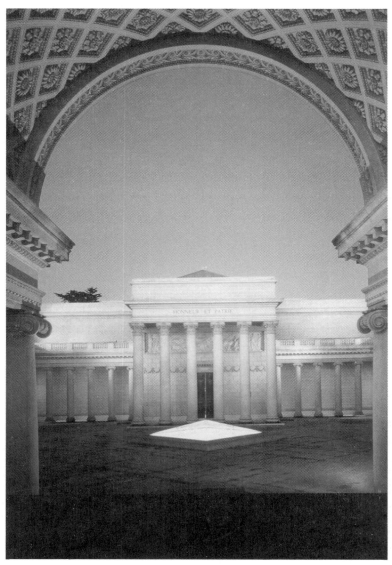

California Palace of the Legion of Honor.
Photo by Richard Barnes, courtesy of the California Palace of the Legion of Honor.

Salm where Napoleon established the order of the Legion d'Honneur. Mrs. Spreckels fell in love with a replica of the building at San Francisco's 1915 Panama Pacific International Exposition and persuaded her husband to build a permanent edition as a new art museum. The Spreckels gave the museum to the city on Armistice Day, 1924, in honor of the 3,600 Californians who lost their lives in World War I.

The first major work you will see is the glorious 2,700-pound bronze sculpture *The Thinker*, completed in 1880 by Auguste Rodin and cast at the turn of the century. *The Thinker* appeared on Rodin's monumental bronze doors, *The Gates of Hell.* It was conceived as the poet Dante, but evolved to represent all poets and creators. Alma Spreckels purchased the cast directly from Rodin in Paris in 1915. The statue was on view in Golden Gate Park until 1924, when it was moved to the Legion. Mrs. Spreckels gave more than 70 Rodin sculptures to the Legion, which houses the third largest collection of Rodin sculptures in the nation.

In 1948, Mr. and Mrs. Moore Achenbach gave their collection of works on paper to the city. The collection was kept in the Main Library until 1950, when it was moved to the Legion. With generous gifts of other donors the Achenbach Foundation for Graphic Arts has become the largest collection of works of art on paper in the western United States. It is comprised of more than 3,000 drawings, 75,000 prints and 2,000 special collection books from the end of the fifteenth century to the present. Among the artists represented are Van Gogh, Whistler, Matisse, Wyeth, Rembrandt, Daumier, Kandinsky, Degas, Picasso, Warhol, Toulouse-Lautrec, Gauguin, Rodin, O'Keeffe and Goya.

Temporary exhibits can be found on the garden level, where a 9,500-square-foot gallery is divided into six rooms organized around a central, skylit courtyard. The inaugural show, *Picasso the Sculptor,* was the first showing of Picasso's sculptures on the West Coast, and included some on loan from the Musee Picasso in Paris.

Permanent galleries feature 19th-century porcelain, 15th-20th-century tapestries and decorative arts, Renaissance and Baroque Art, and Impressionism. Highlights include Monet's *Water Lilies,* Mary Cassatt's *The Artists' Mother* and George Seurat's *Eiffel Tower.*

The expanded gallery space has allowed for a number of new acquisitions, most notably a stunning tortoise shell inlay table attributed to Andre-Charles Boulle, a 15th-century Franco-Flemish tapestry from the Life of Saint Peter series, Matisse's *Faith, the Model* and Picasso's *Still Life with Skull, Leeks and Pitcher.*

Before leaving, take a moment to admire the stairs and hallways, which have been restored and faced in faux marble, or *scagliola,* panels which resemble marble. The columns and walls are Napoleon marble, and the floors in the grand entrance lobby and vestibule are Tennessee Pink marble, the same flooring found in San Francisco City Hall and Opera House.

Shop: Handsome selection of works representing special and permanent exhibits including Russian porcelain, Murano glass, and Rodin tabletop sculptures of *The Thinker, Adam and Eve* and *The Age of Bronze.*

Cafe: Bistro-style food served overlooking Lincoln Park or on the stone terrace.

M.H. DE YOUNG MEMORIAL MUSEUM

Golden Gate Park

San Francisco

(415) 863-3330

Hours: Wed. 10am-8:45pm; Thurs-Sun 10am-4:45pm

Admission: $6 adults; $4 seniors; $3 youths (12-17); children under 12 free; free Saturday morning and the first Wednesday of the month 10am-8:45pm

The grande dame of San Francisco museums, the de Young is the city's oldest art museum and now recognized as one of the best on the West Coast. The museum was the mastermind of newspaper mogul Michael de Young, publisher of the San Francisco Chronicle, who organized a World's Fair in 1894, using the proceeds to create a fine arts museum for the city. The building itself is modeled after the Court of the Ages at the Panama Pacific International Exposition. The pond in front is the Pool of Enchantment, showing a young boy playing music to mountain lions.

Most of the galleries are clustered around Hearst Court, the magnificent Spanish-style great hall where many dignitaries have dined. This is where President Reagan hosted a state dinner for Queen Elizabeth II and Henry Kissinger addressed a NATO reception. At the far end of the court are galleries of seventeenth to nineteenth century paintings and decorative arts. In one area is a recreated Federal Parlor using architectural elements salvaged from an 1805 house in Massachusetts. Besides a

19th-century lolling chair, you'll see an ornate 18th-century gilded French mantle clock, an early American sofa and several mahogany side chairs. In stark contrast is the neighboring gallery of19th-century Shaker Furniture and Folk Art.

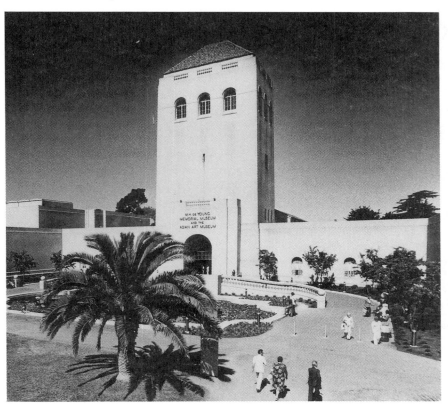

M.H. de Young Memorial Museum in Golden Gate Park, San Francisco. Courtesy of the San Francisco Visitors Bureau.

Perhaps the de Young's greatest treasure is its survey collection of American art, one of the best in the country and beautifully curated throughout several galleries. Over 200 paintings from colonial times through the twentieth century are represented - from George Caleb Bingham's 1846 *Boatmen On the Missouri*

and Grant Wood's masterwork *Dinner for Threshers* to Georgia O'Keeffe's 1925 *Petunias*. Landscapes by Albert Bierstadt, Frederic Church and Thomas Moran are also on display, as well as works by Childe Hassam, James Whistler and Edward Hopper.

Many of the paintings are the gift of Mr. and Mrs. John D. Rockefeller, who contributed their outstanding private collection of 19th-and 20th century American and folk art to the museum in 1979. An additional 24 paintings were donated in 1992, with works by Gilbert Stuart, Thomas Sully and Thomas Eakins, among others.

In the gallery of Art of the Americas are objects representing Mesoamerica, Central and South America and the West Coast of North American including the largest group of Teotihuacan wall murals outside of Mexico and a ten-foot totem pole from Alaska.

American craftsmanship is also showcased, including Paul Revere's silver Tankard and Frank Lloyd Wright's Tree of Life window. One of the museum's most popular works is the life-size marble sculpture *King Saul*, 1882 by William Wetmore Story.

Over the last few years the de Young has attracted major international exhibitions including *Monet: Late Paintings of Giverny from Musee Marmottan, Teotihuacan: City of the Gods* and *Fabergé in America*. Other memorable exhibits have included *Treasures of Tutankhamun* and *The Search for Alexander*.

As with many of the city landmarks, the museum needs extensive seismic upgrading. In lieu of restoring the existing site, a controversial new building with terraces and a garden-like set-

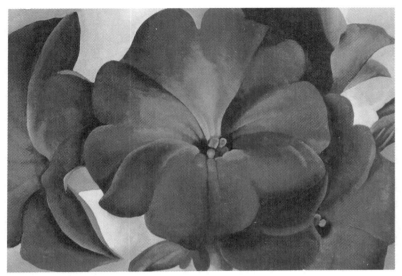

*Georgia O'Keeffe's **Petunias**, 1925. Photo courtesy of the Fine Arts Museum of San Francisco. Gift of the M.H. de Young Family.*

ting has been proposed; the project is contingent on public funding.

Shop: Framed prints, glassware and decorative scarves inspired by museum art as well as the store's own line of paper products highlighting works from the Rockefeller collection of 19th-and 20th century American art.

Cafe: Cafe de Young features soups, salads and sandwiches served indoors or in the sculpture garden.

ASIAN ART MUSEUM

Golden Gate Park
San Francisco
(415) 379-8800

Hours: Wed-Sun 10am-5pm
Admission: $5 adults; $3 seniors; $2 children 12-17; children under 12 free; free admission on the first Wednesday of the month.

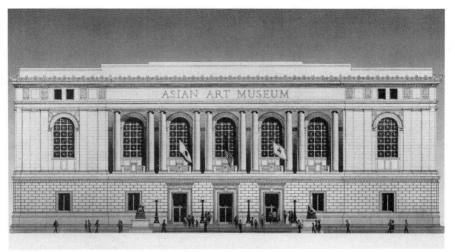

In 1999 the Asian Art Museum's new home will be at the Beaux Arts landmark building, which previously housed the San Francisco Public Library. Photo courtesy of the Asian Art Museum.

San Francisco's position as gateway to the Pacific makes it the ideal site for one of the Western World's richest collection of Asian art, spanning 40 countries and 6,000 years of history and cultures. The Asian Art Museum opened in 1966 with a collection of more than 12,000 sculptures, architectural elements, paintings, ceramics, jades and metalware given to San

Francisco by Avery Brundage, a Chicago industrialist and president of the International Olympic Committee (1952-72). Gifts and purchases have continued to enlarge the collection in all areas.

The museum's first floor galleries showcase the arts of China and Korea; the second floor is dedicated to India, Tibet and the Himalayas, Japan and Southeast Asia. Changing exhibitions feature carved jades from the Neolithic period onward, the oldest known Chinese bronze Buddha in the world (AD. 338), Tang, Sung and Ming dynasty ceramics and sculpture, the largest museum collection of Japanese netsuke and inro, tea ceremony objects and paintings, as well as special traveling exhibitions from museums through the world.

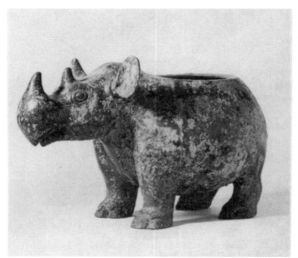

Bronze Rhinoceros Vessel. Late Shang, c.a. 11th century B.C..
Photo courtesy of the Asian Art Museum.

Only a portion of the museum's art is displayed at any time, due to lack of space. In late 1999, the museum will move to the beautiful 1917 Beaux Arts-style former library at the Civic Center, doubling the existing space.

Shop: Asian-themed ceramics, baskets, lacquers and jewelry.

CALIFORNIA
ACADEMY OF SCIENCES

Golden Gate Park

San Francisco

(415) 750-7145

Hours: daily 10 am-5 pm; 9am-7pm Memorial Day
thru Labor Day

Admission: $7 adults: $4 seniors and youth (12-17);
$1.50 children 6-11: children under 6 free; free first
Wednesday of the month.

For over 140 years the California Academy of Sciences has
delighted visitors with its fascinating exhibits. Founded in 1853
just following the Gold Rush, it is the oldest science institution
in the West, and one of the largest natural history museums in
the world. Within its walls are a planetarium, an aquarium and
numerous exhibition halls.

The European-style **Steinhart Aquarium** is home to the most
diverse fish collection in the world, with more than 14,000
species of fish, reptiles, marine mammals and other sea life.
Without a doubt, the biggest draw is the Swamp, located inside
the foyer and a tropical paradise of alligators, lizards and
tortoises living in a replica of their natural habitat. Equally
popular are the Fish Roundabout, which puts you in the middle
of a 100,000-gallon circular tank surrounded by fast-swimming
barracuda, Pelagic rays, bonito and other sea life, and the Touch
Tidepool, where you can pick up live sea urchins, sea

The swamp in the Aquarium at the California Academy of Sciences.
Photo by Caroline Kopp, courtesy of the California Academy of Sciences.

cucumbers, hermit crabs and other tidepool creatures. The Living Coral Reef has tropical corals and coral reef fishes.

Many intriguing exhibits and displays are housed in the **Natural History Museum** as well. One of the newest is **Life Through Time**, a 3.5 billion year journey through life on Earth with giant dinosaurs, flightless birds and other reminders from the planet's obscure past. **Wild California** showcases California. The highlight here is the life-size battling elephant seals set against a 14,000-gallon aquarium and seabird rookery display. At the **African Safari**, you can view magnificent dioramas of African animals in their natural surroundings. The **Gem and Mineral Hall** boasts more than 1,000 specimens, including a 1,350-pound quartz crystal, and **The Far Side of Science Gallery** is filled with Gary Larsen's zany cartoons. For a wild finale, ride Safe-Quake, simulating two of San Francisco's famous tremors (located in the **Earth and Space Hall**).

Morrison Planetarium is Northern California's largest indoor universe and the seventh major planetarium to be built in the United States. Entertaining and educational sky shows are held daily and change regularly. Laserium, a live laser light performance set to rock music, is offered at an additional charge.

The Academy also sponsors special lecture series throughout the year. Conversations & Readings at Herbst Theater has attracted such celebrated speakers as evolutionary biologist Stephen Jay Gould, Pulitzer Prize-Winning author and socio-biologist E.O. Wilson and Kent Weeks, discoverer of Ramses II tomb. The Benjamin Dean Lecture Series focuses on astronomy-related topics.

Shop: Nature-themed items: fish and celestial motif socks and ties, videos on wildlife and the planets, fish mobiles, starfinder kits and glow in the dark star stickers. A separate bookstore is located in the Academy foyer; the Swamp Shop children's store is in the Aquarium.

Cafe: Sandwiches, sodas and other popular snack foods.

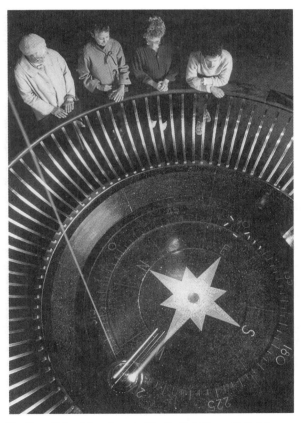

The Foucalt Pendulum is part of the Earth & Space Hall at the California Academy of Sciences. Photo by Susan Middleton, courtesy of the California Academy of Sciences.

CONSERVATORY OF FLOWERS

Golden Gate Park

San Francisco

(415) 666-7017

Interior closed for renovation

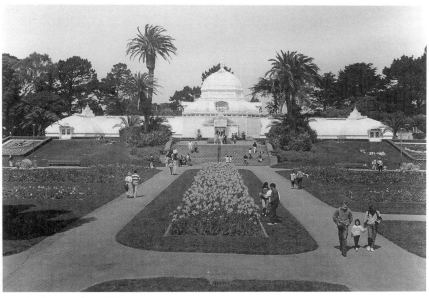

The Conservatory of Flowers.
Courtesy of the San Francisco Convention and Visitors Bureau. Photo by Kerrick James.

Modeled after a conservatory in Kew Gardens London, this glass-domed Victorian building is the oldest in Golden Gate Park (1878), and the oldest conservatory in the United States. It is the only wooden conservatory left in the country and one of only a handful in the world.

The building was commissioned by eccentric millionaire James Lick for his South Bay home. It was manufactured in Dublin, Ireland and shipped to the states in crates. Lick died before the conservatory could be reconstructed. The structure was left to the Society of California Pioneers, which sold it to Charles Crocker and other public spirited citizens who had already agreed to donate it to the park.

Inside, you'll find more than 1,000 native and tropical plants from all over the world, including many rare and endangered species. The giant philodendron planted inside the dome dates to 1883.

At press time, the Conservatory was closed due to extensive structural damage from a storm in late 1995. The Friends of Recreation and Park has established a conservatory fund to raise the estimated $12 million to restore the building, which they hope to reopen in 1999.

Shop: Souvenirs, postcards and books.

TREASURE ISLAND MUSEUM
410 Palm Avenue
San Francisco
(415) 395-5067

Hours: Mon-Fri 10am-3:30pm; Sat-Sun
10am-4:30pm
Admission: $2 adults; children under 12 free

Located on a 400-acre man-made island that was the site of the 1939-40 Golden Gate International Exposition, this Art Deco-style museum was the former administration building and one of only three structures remaining from the fair.

The 1939 Exposition was billed as the "Magic City" and planned to celebrate the completion of the Bay Bridge and Golden Gate Bridge. Thousands of visitors flocked to the island, which had been transformed into an Oz-like land of stucco temples and spires. For 372 days the site was alive with activity.

Then the war came. The Navy took over the site (originally slated to become San Francisco International Airport), and established a military base, turning exposition buildings into barracks or warehouses. After the war ended, Treasure Island remained closed to the public until the museum opened in 1975.

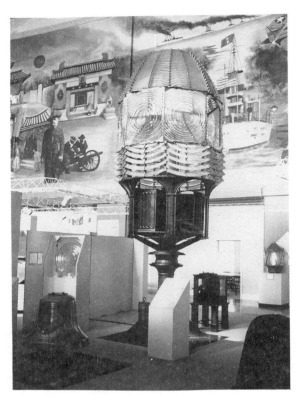

1854 French lens from the Farallon Islands lighthouse; part of the Coast Guard exhibit at the Treasure Island Museum. Note the Naval history mural in the background.
Courtesy of the Treasure Island Museum.

Flanking the entry are six statues, part of the original twenty that circled the Pacific Unity fountain at the fair. Four were destroyed but there are plans to restore the remaining ten. Inside the museum you'll find displays chronicling the history of the island and neighboring Yerba Buena. Depression-era memorabilia, mementos from the fair - including carpet sweepers, pins, clothing and souvenirs - and the America's Seas Service (Navy, Marine Corps and Coast Guard) in the Pacific region are some of what's showcased. A suitcase belonging to a WAVE is just as she had packed it in 1945.

The rest of the space is divided among exhibits on naval battles, lighthouses, including an 1856 working lens from the Farallon Islands, and the legendary China Clipper passenger seaplanes of the '30s.

In 1996 the world's fair gallery was renamed the Zoe Dell Lantis Nutter Gallery in honor of the dancer who donated many of the souvenirs now on display. Lantis traveled the world in 1939 as a goodwill ambassador for the fair.

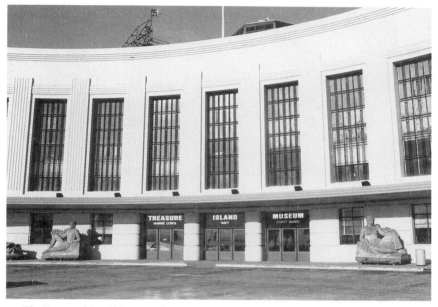

The Treasure Island Museum. Courtesy of the Treasure Island Museum.

Though the military base will vacate the island in late 1997, the museum is scheduled to remain open.

Shop: Naval memorabilia: books, hats, mugs and posters, as well as lighthouse models, GGIE postcards and photos.

Museums & Galleries
of the East Bay

Judah L. Magnes Museum
University Art Museum & Pacific Film Archive
Phoebe A. Hearst Museum of Anthropology
Lawrence Hall of Science
Camron-Stanford House
Oakland Museum
Behring Auto Museum

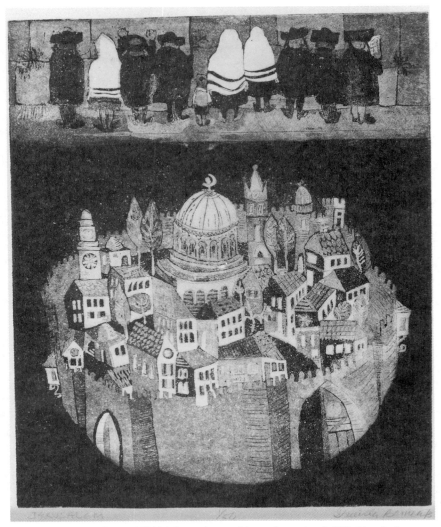

Daniela Barnea (b. Israel 1944-), **Jerusalem,** *etching and aquatint. In* **This Year in Jerusalem: The Passionate Pilgrimage,** *March 24-July 14, 1996 at the Judah Magnes Museum. Photo by Sharon Devauex. Courtesy of the Judah Magnes Museum.*

JUDAH L. MAGNES MUSEUM

The Jewish Museum of the West

2911 Russell St.

Berkeley

(510) 549-6950

Hours: Sun-Thur 10am-4pm

Admission: free

This well-curated museum was originally housed in two rooms above an Oakland movie theater. It moved to its present location in the historic Burke mansion in 1966.

Contained in its permanent collection are over 10,000 objects of Jewish ceremonial art, folk art and fine art from all over the world including paintings, sculpture and drawings by Marc Chagall, Moritz Daniel Oppenheim and other contemporary and traditional artists.

In its early years, the museum sent missionaries to vanishing Jewish communities in Morocco, Tunisia, Egypt and Czechoslovakia to rescue ceremonial art and books. As a result, it has one of the largest Torah binder collections in the nation, an extensive array of North African and European textiles and costumes, documents and artifacts from the Jews of India, a Holocaust collection, and coins, medals and amulets.

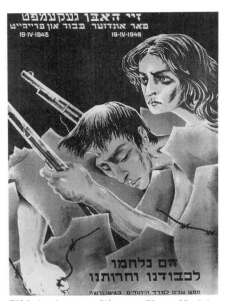

Fifth Anniversary: Warsaw Ghetto Uprising,
1948 color lithograph by Henry Hechtkopf
(Poland), is one of the 50 original posters in
Witnesses To History: The Jewish Poster.
1770-1985. Permanent Collection of prints &
drawings. Photo by Sharon Deveaux. Courtesy of
the Judah L. Magnes Museum.

The Reutlinger and Koshland galleries feature changing exhibits. Recent installations have included favorite Magnes paintings, with works by Max Liebermann, Toby Rosenthal and Maurycy Minkowski, Louis Lozowick lithographs and David Levinthal photographs.

Besides art, the museum is home to the Western Jewish History Center, the largest of its kind in the world and containing thousands of newspapers, periodicals, fine press books and other historic documents on Western Jews from the last two centuries. Housed in the Blumenthal Library are 12,000 rare and illustrated books and manuscripts, thousands of photographs, and Jewish recorded and sheet music.

The museum name pays tribute to San Francisco native Judah L. Magnes (1877-1948), a well-known educator and leader who co-founded the Hebrew University of Jerusalem, the American Civil Liberties Union, the American Jewish Committee, and Hadassah.

Shop: Handcrafted ceremonial objects by Israeli and American artists as well as cards, books, prints and other gift items.

UNIVERSITY ART MUSEUM &
PACIFIC FILM ARCHIVE

2626 Bancroft Way
Berkeley
(510) 642-0808

Hours: Wed.-Sun 11am-5pm; Thurs. 11am-9pm

Admission: $6 adults; $4 seniors and students; children under 12, free; free on Thursday 11-noon and 5-9pm.

This museum is one of the largest university art museums in the world, with six galleries from its own collections and five galleries of changing exhibits. Located in a 95,000-square foot avant garde concrete structure with cantilevered ramps and galleries, the museum is known for its collection of 800 Asian objects, considered one of the best in the nation, as well as its outstanding holdings of pre-Twentieth Century European and Modern including noted artists Juan Miro, Peter Voulkos, Georges Roualt and Francis Bacon; one gallery is devoted to Hans Hofmann. In 1995, twelve major works of modern art were given to the museum including a 1912 cubist drawing by Fernand Leger, a 1950 mobile by Alexander Calder, a 1952 painting by Sam Francis and a 1970 pop sculpture by George Segal.

Housed in the same building is the **Pacific Film Archive**, one of only five world-class film archives and offering one of the nation's largest film exhibition programs. Works range from

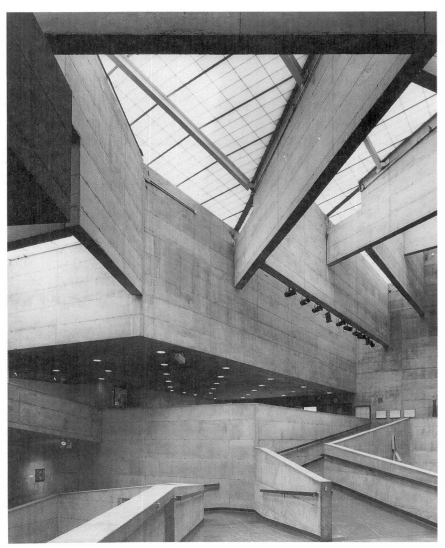

Interior skylights, University Art Museum and Pacific Film Archive.
Photo by Ben Blackwell. Courtesy of the University Art Museum and Pacific Film Archive.

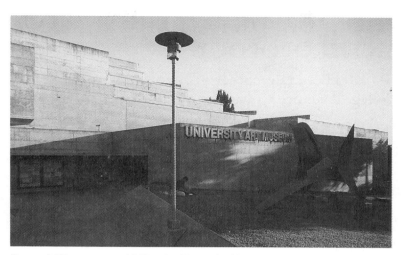

Brancroft Way entrance with Hawk of Peace by Alexander Calder (1968), University Art Museum and Pacific Film Archive, UC Berkeley. Photo by Ben Blackwell. Courtesy of the University Art Museum and Pacific Film Archive.

independent film producers and rare prints of classic cinema to retrospectives of world cinema. Public film screenings are held nightly. A library contains more than 7,000 titles including documentaries, silent movies and children's films.

In 1996, PFA celebrated its silver anniversary; luminaries Francis Ford Coppola, Wayne Wang and John Landis helped to plan the celebration.

Bookstore: Obscure and mainstream books on film, film makers, art theory, criticism and architecture. Cards, posters and hard-to-find foreign exhibit catalogs are also for sale.

Cafe Grace: Healthy, gourmet items served indoors or in the sculpture garden.

PHOEBE A. HEARST MUSEUM OF ANTHROPOLOGY

103 Kroeber Hall, corner of Bancroft Way and College Avenue, University of California at Berkeley
Berkeley
(510) 643-7648

Hour: Wed., Fri.-Sun. 10am-4:30pm.; Thurs. 10am-9pm

Admission: $2 adults; $1 seniors and $.50 children 16 and under; free on Thursdays.

Phoebe A. Hearst founded this teaching and research museum in 1901 in a small cottage on the Berkeley campus. Hearst, a former school teacher, loved education, especially anthropology and Classical and Egyptian archaeology. In 1895, she purchased several collections for the University of Pennsylvania Museum, transferring these to the University of California at the turn of the century.

Hearst sponsored major expeditions in hopes of establishing a museum. The objects found on these expeditions are the foundation of the museum's holdings. From Egypt, there are artifacts covering the pre-dynastic era to the New Kingdom; a collection of Native California artifacts includes more than 250,000 items and is the largest in the world. The museum represents nearly every culture, past and present, including the Arctic, Africa and Oceania.

From the exhibit— Tibetan Voices: Portrait of a Culture in Exile. Photo by Alison Wright. Courtesy of The Phoebe A. Hearst Museum of Anthropology.

Shop: Books on ethnology and archaeology as well as arts, crafts, jewelry and cards which reflect the museum's holdings. There is a large selection of work by contemporary Native Californian artists - jewelry, baskets, games and wood carvings.

LAWRENCE HALL OF SCIENCE

Centennial Drive
University of California, Berkeley
(510) 642-5132

Hours: Open daily 10am-5pm
Admission: $6-adults; $4students and seniors;
$2 children 3-6 years

*Giant DNA model: children climb on one of the world's largest models of a DNA molecule, 5.5'
tall and 60 ' long, now at U.C. Berkeley's Lawrence Hall of Science. The scientifically accurate
climbing and learning structure is over 8 million times larger than the real thing: if someone had
DNA this large, she would be standing with one foot in Berkeley and the other in Honolulu!
Photo courtesy of Lawrence Hall of Science.*

Located at the University of California in the Berkeley hills, the
Lawrence Hall of Science hosts a spectacular view of the entire
Bay Area. Dedicated to increasing the appreciation and
knowledge of science and mathematics, the Lawrence Hall of
Science was opened to the public in 1968 as a living memorial
to Ernest O. Lawrence (1901-1958), the inventor of the
cyclotron and the University's first Nobel Prize winner (1939).

The center is a must see. Interactive exhibits let the visitor

become the scientist and explorer, with topics ranging from dinosaurs to space travel. Whether you are a science person or not, this center will stimulate your curiosity to learn more.

Ongoing exhibits include:
Within the Human Brain. Lets you step into simulated "rat cage" of learning experiments and explore how your brain responds.

Laser: The Light Fantastic. Find out about laser beams. Explore holograms, work a supermarket-style laser, and make your own light show.

1492: Two Worlds of Science. Explore the science and technology that existed in the Americas and Europe during the time of Columbus.

Math Rules! An exciting and enjoyable assortment of hands-on puzzles and activities for all ages that will stretch your mathematical way of thinking.

Other ongoing exhibits are: *30-foot robotic dinosaur* • *earthquakes* • *a two story high computerized Periodic Table of Elements* • *gems and minerals collection* • *artifacts chronicling the work of Ernest O. Lawrence.*

In addition, there are exciting **outdoor exhibits** which include: *Pheena, a life-size whale* • *giant 60 foot long DNA helix* • *Sunstones II precisely positioned to mark astronomical events* • *Spectral wave prisms* • *Wind Organ* • *The Fallen Giant (remains of a giant redwood).*

Shop: The center houses a gift and book store including the many publications by Lawrence Hall of Science.

Cafeteria: Located on the lower level. Snacks, sandwiches, soups, salads and meals are available.

CAMRON-STANFORD HOUSE

1418 Lakeside Drive
Oakland
(510) 836-1976

Hours: Wednesdays 11am-4pm
and Sundays 1pm-5pm
Admission: nominal, children 12 and under free

Overlooking Lake Merritt from a tree-shaded lawn, this magnificent Italianate Victorian structure was built in 1876 and is the only one of its kind remaining on the shores of the lake.

The house was originally built for Will W. Camron and his wife, Alice. Saddened by the premature death of their baby, the couple moved a year later and rented it to socialite David Hewes. Hewes donated the golden spike to join the two parts of the transcontinental railroad.

Josiah Stanford, brother of Leland Stanford, Sr. the founder of Stanford University, bought the house as the family's in town residence. In 1907 the city of Oakland purchased it for $40,000 and turned into a public museum.

When the new downtown museum complex was constructed the house was closed. In 1971, the Camron-Stanford House Preservation Association was formed to restore the building, which reopened in 1978.

Visitors can take a 45-minute tour of the house. Besides a formal dining room, there are three gorgeously restored parlors, one of which has Turkish furniture and a fireplace that belonged to Samuel Merritt. Another parlor has copies of European Renaissance masterpiece paintings and sculpture collected by Hewes while touring Europe.

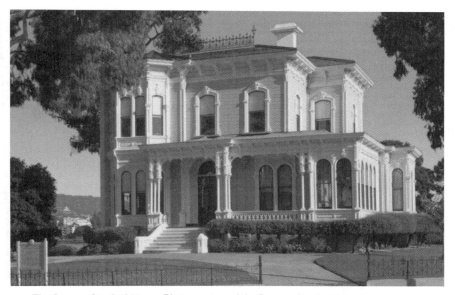

The Camron-Stanford House. Photo courtesy of the Camron-Stanford House.

Shop: Located on the ground level, this small shop sells postcards and photographs.

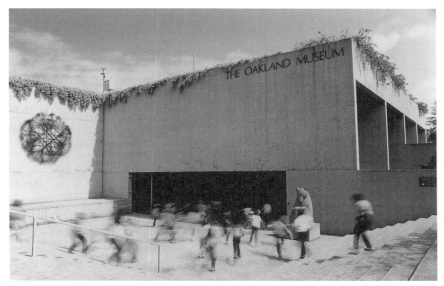

Eager visitors to the Oakland Museum of California are welcomed by Beniamino Bufano's polished granite sculpture **Bear Nursing Cubs**, *n.d.*
Courtesy of the Oakland Museum. Photo by Joe Samberg.

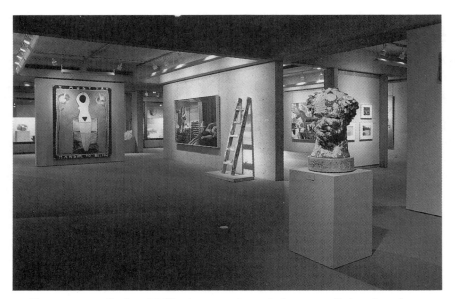

The permanent collection of California art contains works in many media from the early 19th century to contemporary times. A view of contemporary art.
Photo courtesy of the Oakland Museum.

THE OAKLAND MUSEUM

The Museum of California
1000 Oak Street
Oakland
(510) 238-3401

Hours: Wed-Sat 10am-5 pm; Sun 12noon -7pm

Admission: $5 adults; $3 seniors and students; children under 6 free; free Sunday 4-7pm

Opened in 1969, this splendid three-tiered museum designed by architect Kevin Roche is dedicated to California's art, history and environment. It is renowned for its post-modern architecture, which covers four city blocks and includes beautifully land-scaped interior gardens, courtyards, ponds and terraces.

The museum is actually the amalgamation of three museums: The Oakland Public Museum, the Oakland Art Museum and the Snow Museum of Natural History, all reorganized into one building and around one theme: the state of California. Inside are galleries representing California art, from early settlers to contemporary artists; California history; and California ecology.

On the first level is **The Hall of California**, a 38,000 square-foot exhibit area representing each of California's eight biotic zones: Coastline, Coast Mountains, Inner Coast, Interior Valley, Sierra Slope, High Sierra, Great Basin and Desert. The gallery is

arranged so that visitors take a simulated walk across California, from the Pacific Ocean to the Sierra Nevada. Topographical models show the physical characteristics of each area.

The **Aquatic California Gallery** presents California's aquatic regions, including the ocean, fresh water and estuaries, hot springs and snow banks. Issues in California environmentalism are represented as well. Also on the first level is the **Natural Sciences Special Gallery**, where a wildflower show is held each spring.

On the second floor is **The Cowell Hall of California History**, a 28,000 square-foot gallery looking at California's history chronologically through craftwork, tools, printed material, decorations, costumes, furniture, clothing and vehicles that have shaped the state. Four different phases are covered: Indian; Spanish-Mexican; American (from early explorers through the Gold Rush, Victorian era and the 1906 earthquake); and 20th century.

Paintings, sculpture, prints and photographs by California artists or artists dealing with California themes can be found in the third-floor **Gallery of California Art**. The decorative arts collection is especially remarkable with sketches and paintings by early explorers, panoramic landscapes and Impressionist, Abstract Expressionist, Figurative, Pop and Funk works. While only 500 artworks are on display at any given time, the collection numbers more than 80,000 works.

In the **Hall of the Pacific Rim** you'll find the Helen Pritchard Chinese Snuff Bottle Collection, as well as the spectacular jade pagoda, carved from a single piece of translucent Burmese jadeite

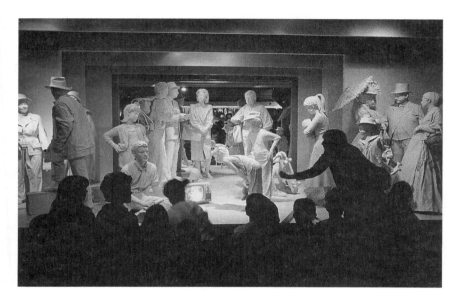

Children explore the enigma of Larry Bell's scultpure, Untitled, 1967. Its sides of coated glass, plexiglas and metal stripping alternately block, reflect and refract light, and even, at times, mirror the viewer. Courtesy of the Oakland Museum. Photo by Joe Samberg.

The museum also owns the world's most extensive archive of work by documentary photographer Dorothea Lange. In 1998, a major exhibit will commemorate the 150th anniversary of the Gold Rush.

Shop: Western art books and natural history guides plus cards, gifts, jewelry, toys and t-shirts. The Collectors Gallery rents and sells original works by California artists and artisans.

Cafe: Gourmet salads, sandwiches, entrees and snacks in a Craftsman-style setting overlooking the ivy-clad courtyard.

BEHRING AUTO MUSEUM

3700 Blackhawk Plaza Circle
Danville
(510) 736-2280

Admission: $7 adults; $4 seniors and students
Hours: Wed-Sun 10am-5pm
Docent tours Saturdays & Sundays at 1pm.

If you ever wanted to see the 1925 yellow Duesenberg in which Clark Gable courted Carole Lombard or Rudolph Valentino's 1926 Isotta Fraschini roadster, this is the place.

Set in a beautiful shopping mall near the exclusive community of Blackhawk, the spectacular 63,000-square foot Behring Museum is considered to be one of the most comprehensive assemblages of vintage automobiles in the world. More than 120 cars from the 1890s to 1970s rotate regularly including the gray Mercedes-Benz armored staff car Hitler used to enter Poland, the 1924 Hispano-Suiza Tulipwood racer in which French aperitif heir Andre Dubonnet roared across Europe, Aga Khan's 1952 Rolls Royce Phantom and the Shah of Iran's 1939 Bugatti.

The museum was founded in 1983 by automobile aficionado and real estate developer Kenneth E. Behring, who affiliated his namesake Educational Institute, Inc with UC-Berkeley to preserve and exhibit historic cars. The $100 million car collection and the stunning $30 million multi-level granite and glass structure are Behring's contribution.

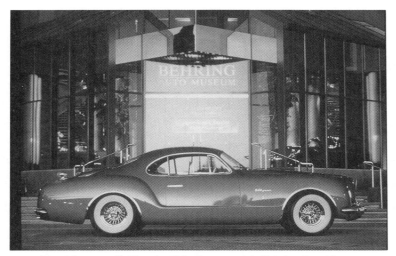

1954 DeSoto Adventurer II. Photo by Ghia. Courtesy of the Behring Auto Museum.

Besides vintage cars, the museum also houses the W.E. Miller Automotive Research Library, named for West Coast automotive designer Wellington Everett Miller, who built custom cars for movie celebrities such as Douglas Fairbanks, Mary Pickford, Rudolph Valentino and Tom Mix. Over the years Miller collected more than 2,000 automotive books, 35,000 periodicals dating to the 1890s and thousands of photos and negatives, now part of the Library holdings.

The Behring Automotive Art Collection represents automotive fine art and automobilia dating to the late 1850s. On display are automotive-themed paint and ink works, metalworks, ceramics and mixed media demonstrating the social and historical influences automobiles have had on the world.

Shop: Automotive books and posters, diecast models, ready-to-assemble automotive kits in plastic and metal and other automotive-related items.

Museums & Galleries
of Marin County

Bay Area Discovery Museum
Bay Model Visitor Center
Muir Woods National Monument
San Quentin Museum
Marin Museum of the American Indian
Marin Art & Garden Center

BAY AREA DISCOVERY MUSEUM

557 E. Fort Baker

Sausalito

(415) 487-4398

Hours: June 15-Sept. 15 Tu-Sun 10am-5pm; Sept. 16-June 14 Tu-Thur 9am-4pm; Fri-Sat 10am-5pm

Admission: $7 adults; $6 children 1-18; children under 1 free

Maze of Illusions, Bay Area Discovery Museum. Photograph by Carolina Kopp. Courtesy of the Bay Area Discovery Museum.

Once an old army base, this colorful museum is housed in not one but eight restored buildings nestled in a cove on the grounds of the Golden Gate National Recreation Area. The complex was

awarded a National Historic Preservation award in 1992 for creative use of facilities.

Exhibits appeal to youngsters of all ages. Aspiring architects can build a futuristic house in the Architecture and Design building. Wannabe movie producers can make their own videos in the Media Arts Lab, and in the Media Center kids can communicate with people all over the world.

Classes, workshops and nature walks are offered throughout the year. The grounds have a wildflower and butterfly reserve, sculpture garden built by and for children, and a picnic area with a view of the Golden Gate Bridge.

Discovery Store: Excellent selection of educational toys, books and games.

Discovery Cafe: Sandwiches, soups and snacks. A birthday room is available to rent.

Bay Model Visitor Center.
Photo courtesy of the Bay Model Visitor Center.

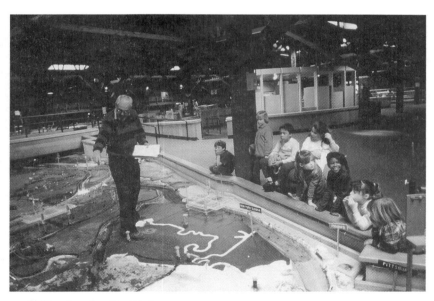

Children learning about the bay.
Photo courtesy of the Bay Model Visitor Center.

BAY MODEL VISITOR CENTER

2100 Bridgeway Blvd.
Sausalito
(415) 332-3871

Hours: Tue-Sat 9am-4pm; Memorial Day to Labor Day Tue-Fri, 9am-4pm; Sat and Sun from 10am-6pm.

Admission: free

Parents who remember field trips to the San Francisco Bay-Delta Model are now showing their children this Marin landmark.

On the site of what was once a World War II shipyard, the Bay Model was built in 1956 by the U.S. Army Corps of Engineers to study the effects of man and nature on the bay. An engineer can examine, in a laboratory setting, the effects of deepening ship channels and use the information to prevent harmful effects on the bay environment.

Though the three-dimensional model is not an exact replica of the bay or delta, its action is similar. The model recreates bay conditions and reproduces the rise and fall of tide, flow and current of water and mixing of salt and fresh water. Engineers have used the model to study the effects of fill, pollution and fresh water on this environment. Many say the model may have helped save the bay.

Start by picking up a map and self-guided tour at the Visitor Center entry. Then follow the ramp to view a short video before exploring the exhibits. The Model is big - more than an acre in size - so there's a scaled model to help visitors get their bearings. Colors identify the different land uses. *Red=* roads & bridges; *dark brown* = uplands; *light green* = marshes, mudflats & diked islands; *light brown* = cities & towns; *grey* = industry; *dark green* = parks. Throughout the mazelike area are interactive exhibits and computer games designed to entertain and educate you about the bay: the rise and fall of tides, what kind of animals live in the mudflats, and equipment used to monitor and maintain the waters.

After touring the Model, stop by the Marinship 1942-1945 Exhibit, a historical monument to the remarkable shipyard located here in World War II. More than 75,000 Americans poured into Marin County to help build the warships. Workers produced a completed vessel every 13 days, with everyone working a minimum of six days a week. When peace was declared, Marinship was turned over to the U.S. Army Corps of Engineers, which developed a few of the buildings as the Bay Model and Marinship exhibit.

Also of interest is the old pier where the historic 1915 *Wapama*, a rugged steam schooner built for the lumber trade, and the *Hercules*, a 1917 ocean-going tug are docked.

Shop: Books related to science, marine life and Marin County as well as postcards and posters.

Cafes: No cafe, but Sausalito has a variety of delightful cafes and restaurants.

MUIR WOODS NATIONAL MONUMENT

Mill Valley

(415) 388-2595

(12 miles north of the Golden Gate Bridge reached by U.S. 101 and Calif. 1)

Hours: daily 8am-sunset

Admission: free

To avoid crowds, consider visiting early or late in the day, midweek or from October to April.

No trip to Marin would be complete without a stop at Muir Woods. This magnificent living museum boasts a large assemblage of giant coastal redwood trees, some more than 1,000 years old. It is the only forest in existence that has never been logged.

The history of Muir Woods goes back to the early 1900s when it was known as Redwood Canyon and threatened with destruction. William Kent, later elected a U.S. Representative, looked upon the trees as an irreplaceable source of beauty. He purchased the canyon in 1905 for $45,000 with the intent of preserving it. When the canyon was threatened again in 1907 by the North Coast Water Company, which proposed to log the trees to create a reservoir. Kent took the problem to President Teddy Roosevelt. He also offered to donate this nationally significant forest. Roosevelt accepted, and in 1908 Muir Woods was proclaimed a National Monument. Kent's only condition was that the new park be named in honor of the great naturalist John Muir.

Although there are six miles of walking trails, the best way to tour the 560-acre park is to walk up one side of the creek, cross one of the bridges and return on the other side. It takes about 20 minutes to walk to the second bridge and return, about 45 minutes to go to Cathedral Grove and return by the third bridge, and about an hour to go to the fourth bridge. Trails lead out of the canyon and connect to those on Mt. Tamalpais for longer hikes.

One of the most popular destinations is Bohemian Grove, dating to the 1880s. Jack London, Gertrude Atherton and other "bohemian" literaries held all-night poetry readings, one of which was held in this grove, hence the name. The experience was so moving that at one point the group considered buying the property. It is here the biggest redwood in Muir Woods — a 253-feet tall tree, 13-feet in diameter — is located.

The fallen tree near Cathedral Grove used to be the famous "walk through" tree, which crashed in 1971, breaking into four pieces. Also in this grove the new United Nations met in 1945 to honor the late FDR and commit themselves to people living peacefully in nature.

As you walk along Redwood Creek look for fish which are either coho salmon or steelhead trout. The creek has the last remaining native stocks of these species, known as *anadromous* because

Silver salmon spawn after winter rains.
Photo by James Morley. Courtesy of the National Park Service.

they spend part of their lives in salt water and part in fresh water. Visit just after a winter rain to watch adult salmon spawning. At other times of the year, look for spring wildflowers or clustering ladybugs.

When visiting the forest wear comfortable walking shoes and bring a jacket. Muir Woods is cool and damp year-round, with daytime temperatures averaging between 40° and 70°.

Peace and beauty on the Muir Woods Trails. Courtesy of the National Park Service. Photo by James Morley.

Shop: Books on John Muir plus videos, tapes and posters on Muir Woods. The park displays in the visitor center are worth visiting, too!

Cafe: Snack bar and gift shop are just inside the park entrance. Or bring a picnic and take it to nearby Muir Beach.

This trip may be combined with the San Francisco Bay/Delta model.

SAN QUENTIN MUSEUM

Building 106, Doloros Way
San Quentin
(415) 454-8808

Hours: Mon, Wed, Fri 10am-1pm; Tu, Thur
11am-3pm; Sat- Sun 11:45am-3:15pm
Admission: $2 adults; $1 seniors
and children under 12

If you've ever wanted to go behind prison walls, this is your chance. California largest and oldest prison, San Quentin, has a small, but well maintained museum opened in 1992 to document the penitentiary's fascinating 150-year history.

San Quentin was established during the Gold Rush, when a surge in California's population resulted in vigilantism and high crime. State officials commissioned two entrepreneurs to operate a private penitentiary in an old barge without cost to the state in exchange for free labor from the prisoners. The conditions were deplorable; many inmates went without shoes and proper clothes. The state took over the operation in 1858, establishing a prison school and training prisoners to build roads and work in forestry camps. When the Department of Corrections was founded in the early 1900s, a new mess hall, arsenal tower, administration building and the world's largest single cell block were constructed. Today the prison houses some 3,000 inmates.

Inside the museum you'll find thumb and ankle cuffs, leg irons, batons and other reminders of prison life. Vintage photographs of the furniture factory, a women's cell and the inmate marching band are also on display.

The museum is located on prison grounds so strict rules of conduct are enforced. Cameras, knives and jeans (prisoners wear jeans and denim shirts) are prohibited.

Shops: Souvenir items: t-shirts, mugs, shot glasses and jewelry including shackle and lock and key earrings are sold in the shop adjoining the museum. Located just outside the prison walls is the San Quentin handicraft store which sells items made by the inmates including cable car music boxes, money clips and clocks.

MARIN MUSEUM OF THE AMERICAN INDIAN

Miwok Park

2200 Novato Blvd., Novato

(415) 897-4064

Hours: Tu-Fri 10-3; Sat-Sun 12-4

Donation

Some experts believe archeological sites in Marin County date back to 6000 B.C. One museum dedicated to educating the public about the area's early history is the Marin Museum of the American Indian, founded in 1973 on an archeological site of Coastal Miwok origin.

Located in its original building, the museum has rotating and permanent exhibits dedicated to the history and culture of Native American Indians. One of the most innovative is the "hands-on" Touching Display, assorted cubby holes filled with baskets, shells, animal skulls and skins. Kids of all ages are encouraged to pick up and handle the objects to see and feel how traditional materials and tools worked. The superb Toys, Tools & Treasures has miniature artifacts made by Native Americans including teepees, boats and canoes, mortars and pestles and toys.

Special events and lectures are scheduled around the exhibits—

Photo courtsey of the Marin Museum of the American Indian.

from making Pomo-style baby carriers to talks on the meaning of ceremonial robes and masks. Each September, Trade Feast is held, with Native American dance and craft demonstrations, plus traditional foods.

Shop: Jewelry, t-shirts, arrowheads, bows and arrows, games, books and other items related to Native Americans.

No cafe, but the grounds have picnic tables, barbecue pits, a playground, bocci ball and horseshoe pits, a creek and expansive lawn.

MARIN ART AND GARDEN CENTER

30 Sir Francis Drake Blvd.

Ross

(415) 454-5597

Hours: 9am-5pm; grounds open until sunset

Admission: free

This lovely jewel situated on the former Mexican land grant "Rancho Punte de Quentin," was once owned by James Ross, for whom the town of Ross is named and who settled here in 1859. Ross's daughter Annie married George Worn and the two built a home on a portion of the property which is now the Marin Art & Garden Center.

The Octagon House was the first building constructed and served as a tank house over a well. It was the Worn's temporary home until the main house was built in 1865.

In 1931, the main house was destroyed by fire, leaving only a barn and the Octagon House. The property was unoccupied for 15 years until Caroline Livermore and several old Marin families raised enough money to purchase the property, restoring it as a community cultural center.

Today the grounds contain an art gallery, antique shop,

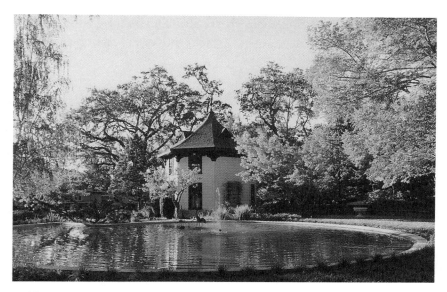

Marin Art and Garden Center.
Courtesy of the Marin Art & Garden Center.

restaurant and amphitheater. In 1968, Helen Moya del Pino
had the Octagon House completely restored as a tribute to her
husband Jose Moya del Pino, one of the founders of the center.
The building was moved away from the well to its present site
and walls were stripped to reveal the original tongue and groove
wood. The second floor was replaced by a stunning balcony and
a view of the original ceiling. The chandelier is from
Williamsburg and the circular iron staircase from North
Carolina. The beautiful bookcases and furniture are custom
made. The building now serves as the Art and Garden Reference
Library.

The center itself is actually an arboretum. The Worns loved
gardening and planted many beautiful trees, including the
magnolia tree which dominates the center of the grounds. The
sequoia, with its rounded top, was brought from Yosemite by

the Worns as a small tree in the 1880s. The doming is unusual because it usually takes place when the trees are over one thousand years old.

The center was acquired in 1945 with the idea that it would serve as a living memorial to the dead, particularly those who had sacrificed their lives in serving their country. One of the first memorials was the giant sequoia tree planted as a tribute to Marin residents who lost their lives in World War II. Near the Gallery is a Dawn Redwood, in memory of a prominent Marin artist. This species was thought to be extinct until 1946 when a paleontologist brought back tiny cones from China which ended up at a Christmas Greens Sale at the center. Near the Octagon House is the "Memory Garden," tended by the Marin Garden Club.

Decorations Guild: Run by volunteers and selling handmade bouquets, wreaths, tree plaques and other garden gift items. Proceeds benefit the center.

Ross Garden Restaurant & Patio: A cottage restaurant tucked among the trees with a changing menu and complimentary fashion shows held from May to October.

Ross Valley Players: Year-round community theater in the historic barn.

Museums & Galleries
of
the Peninsula &
the South Bay

Coyote Point Museum
Hiller Museum of Northern California Aviation History
Hoover Tower
Stanford University Art Museum
Stanford University Art Gallery
Allied Arts Guild
Palo Alto Cultural Center
Barbie Doll Museum
Palo Alto Junior Museum & Zoo
Museum of American Heritage
Filoli
Lace Museum
Triton Museum of Art
de Saisset Museum
San Jose Museum of Art
Egyptian Museum & Planetarium
Children's Discovery Museum of San Jose
Tech Museum of Innovation
American Museum of Quilts & Textiles
Winchester Mystery House
McPherson Center for Art & History

Housing Area — The many creatures, large and small, that can live in an oak woodlands zone is part of the teaching about the environment found in this ecological zone on display at Coyote Point Museum. Photo by Ernest Braun. Courtesy of the Coyote Point Museum.

COYOTE POINT MUSEUM

For Environmental Education
Coyote Point Recreational Area
1651 Coyote Point Drive, San Mateo
(415) 342-7755

Hours: Tu-Sat 10 am-5pm; Sun 12noon-5pm

Admission: $3 adults; $2 seniors; $1 children (under 6 free); free first Wednesday of the month.

It's hard to believe that this stunning 28,000 square-foot Douglas fir museum was once housed in a small quonset hut/ warehouse on the campus of a local junior college. Now the expansive skylighted space boasts an 8,000 square-foot exhibit hall, classroom, library, offices and store.

The multi-level permanent exhibition area is the centerpiece of the museum and filled with computer games, live insects, and fish displays to explain the six major ecosystems found in the Bay Area: the redwood and broadleaf forests, grasslands, chaparral, baylands and coast. Dioramas, games, and visual aids in telling the story of our evolution and our planet. An outdoor wildlife center has a bird aviary, butterfly garden and small wildlife habitat housing badgers, porcupines and other indigenous animals.

This is a place where you'll want to spend the day. The museum is part of the Coyote Point Recreation Area and there are

beaches, grassy areas for kite-flying, tree-shaded strolling paths and picnic tables galore. Throughout the year special family events are held, including a Halloween Fest, Mushroom Fair, Reptile Festival and Gingerbread House contest.

Shop: Outstanding selection of educational toys and books related to nature and wildlife. Also crafts, botanical t-shirts, bird house ornaments and other outdoor-theme items.

I'm Ignoring You — A tiny burrowing owl turns its back on a youngster who can get a nose-to-beak look at the bird through a pop-up tube located within the owl's habitat. It is just one stopping point on a tour of Coyote Point Museum's Wildlife Habitats. Photo courtesy of the Coyote Point Museum.

HILLER MUSEUM OF NORTHERN CALIFORNA AVIATION HISTORY

San Carlos Airport
601 Skyway Rd., San Carlos
(415) 654-0200

Hours: museum opens in 1997
Admission: to be determined

Plans for the future museum.
Courtesy of the Hiller Museum of Aviation.

Someone once called this place aviation history's equivalent of grandma's attic. Located in a nondescript Redwood City warehouse until it moves to its new 50,000-square-foot facility in 1997, the Hiller Museum houses more than 76 aircraft and related reminders of Northern California's importance in aviation history.

The museum is the brainchild of Stanley Hiller, Jr., an engineering genius, who at the age of 19 built an early helicopter in a friend's garage. He turned the design into Hiller Aircraft Co., employing some 2,000 people and producing more than 3,000 helicopters.

Hiller wanted to bring public awareness to the aviation mile-

stones that have taken place in the Bay Area, including the 1869 flight of the Avitor, the first powered, unmanned heavier-than-air craft to fly successfully, and the first takeoff and landing from a ship, the Naval cruiser Pennsylvania in San Francisco Bay in 1911. He assembled memorabilia from these and other local aviation moments, which have become the foundation of the museum's holdings.

Photo courtesy of the Hiller Museum of Aviation.

HOOVER TOWER

Serra Street
Stanford University
(415) 723-4311

Hours: daily 9am-5pm
Admission: free

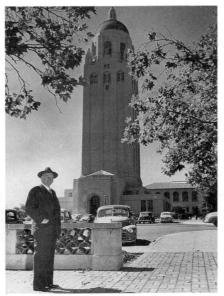

Herbert Hoover in front of the Hoover Tower. Courtesy of The Hoover Institution.

The majestic 279-foot Hoover tower, named after and built by Herbert Hoover who was a geology major at the University, is actually offices and a library. It is home to the "Institution of War, Revolution and Peace," often referred to as a "think tank" for Presidents. A copy of the Communist Manifestor is kept here in addition to many rare revolutionary works.

On the lower level you'll find a small, but intriguing two-room museum of Hoover memorabilia. One area is devoted to Hoover's wife, Lou Henry, who collected classic Chinese blue and white porcelain during the early years of their marriage. Several cases are filled with dishes and jars from the Ming and Ch'ing Dynasty (1368-1644) in addition to precious Belgian lace and tapestries.

The second space pays homage to Herbert Hoover with books, old photographs and other artifacts from his life.

STANFORD UNIVERSITY ART MUSEUM

Lomita Drive & Museum Way
Stanford
(415) 723-4177

Admission: free. Fee for traveling exhibits

As we go to press, the spectacular $31 million renovation and expansion of the Stanford University Art Museum - badly damaged in the October 1989 earthquake - is underway, with completion set for 1998.

When finished, the 78,000 square root building will include a new 40,000-square foot wing housing a cafe, book shop and lecture hall in addition to 12,000 square feet of gallery space. A sculpture garden court will link the wing to the historic building.

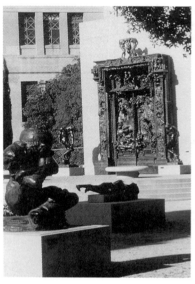

In the outdoor section, one can view The Gates of Hell by Auguste Rodin. Bronze, Coubertin Foundry, no.5. Photo courtesy of the Stanford University Art Museum.

The museum was originally built in 1891 and patterned after the National Archaeological Museum in Athens. As the story goes, Leland Stanford Jr. loved art and vowed to one day create a world-class museum. He visited the Archaeological Museum in Athens and was so enamored with its neoclassical facade, Ionic columns and inner courtyard, that he decided to model his

museum after it. The young Leland died in 1884 at the age of 15. His mother, Jane Stanford, took charge of the project, fulfilling the young boy's wishes.

While the new museum will place more emphasis on contemporary art, it will feature works from all historical eras. The south rotunda will again house Rodin sculptures, and the lobby - with its marble walls, staircase and mosaic tile floor - and galleries will look much the same as they did before the quake.

New garden areas and the enhancement of the magnificent Rodin Sculpture Garden are included in the project. The sculpture garden was founded in 1985 after arts patron B. Gerald Canter gave the university 185 Rodin sculptures including *The Thinker, The Gates of Hell and Burghers of Calais*. This is the largest collection of Rodin sculpture outside the Musee Rodin in Paris.

Though the museum is closed, you can still tour the sculpture garden and main quad, created by Frederick Law Olmstead who designed New York's Central Park. The Memorial Church, which reopened recently after an extensive restoration, has one of the largest gold leaf and mosaic facades in the nation. A mosaic near the altar is one of three copies of the original in the Sistine Chapel. The sayings along the wall are Mrs. Stanford's philosophy on life.

The campus itself is a superb outdoor gallery of sculptures by Joan Miro, Henry Moore and Josef Albers. Aristedes Demetrios created the free-form Memorial Fountain in White Plaza. Guided sculpture tours are offered the first Sunday of the month at 2pm. Rodin sculpture tours are every Saturday and Sunday at 2 pm.

STANFORD UNIVERSITY ART GALLERY

Serra Street, near Hoover Tower
Stanford University
(415) 723-2842

Hours: Tu-Fri 10am-5pm; Sat-Sun. 1pm-5pm
Admission: free

The Stanford family art legacy goes beyond the renowned university art museum to the lesser-known Thomas Welton Stanford Art Gallery, near Hoover Tower. Built in the Moorish style, the gallery is named for Leland Stanford's brother, Welton, who over the course of his life had acquired a large number of Australian landscapes and paintings while living in Melbourne. Welton Stanford wanted to ensure that the paintings would be preserved and donated them to the Stanford University Museum of Art. His namesake gallery was built following his death in 1918. Unfortunately, most of the Australian landscapes have since been lost, stolen or destroyed.

The gallery now features changing exhibitions, predominately from the university's permanent collection. Recent shows have included *American Modernism from the 1920s to the 1960s* from the Lois Q. Spreckels collection, *The Enduring Illusion; Photographs from the Stanford University Museum of Art* with works by Edward Weston, Imogen Cunningham, Alfred

Stieglitz, and Julia Margaret Cameron, and *Our Art, Our Voices,*
assembled by Stanford's Native American alumni. A year-long
multi-cultural show on the figure as art will open in late 1996.

When the University Art Museum reopens, the Stanford Art
Department will take over the gallery and renovate the space as
studios.

Shop: Books, postcards and small gift items related to art.

Stanford University Art Gallery.

ALLIED ARTS GUILD

75 Arbor Rd.
Menlo Park
(415) 322-2405

Hours: Mon-Sat 10am-5pm
Admission: free

Allied Arts Guild

Tucked back in a quiet tree-shaded neighborhood is the lovely Allied Arts Guild, a romantic composite of Old World buildings and landscaped grounds housing an array of art galleries and shops. The complex was started in 1929 by Garfield and Delight Merner, who became enamored with European craft colonies while traveling abroad. They returned home, bought three and a-half acres of what was once the vast Rancho de las Pulgas land grant, and converted it into an artist's enclave.

Throughout the grounds you'll find flower-filled courtyards inspired by those in Granada and named in the Spanish manner *Court of Abundance, Cervantes Court*, featuring a tile mural of Cervantes dedicating his masterpiece, Don Quixote, and *The Garden of Delight*. Art objects were brought from Spain, Tunis and Morocco.

The murals and frescoes are by the well-known artists of the de Lemis family and Maxine Albro, a student of Diego Rivera. Pedro de Lemis went on to become the director of the Stanford University Art Gallery and Museum. He also helped design the Ramona Street building complex in Palo Alto and other residential sites. Maxine Albro's mural can be found on the walls of Coit Tower.

The Merners preserved many of the original buildings when developing the guild, including the 1885 barn and sheds, several of which remain standing. They added a staircase to the hacienda-style ranch house and turned it into their home. Architect Gardner Dailey designed new buildings in the Spanish Colonial style which now house galleries and shops, as well as weaving, sculpting and pottery studios. The Barn, Wood shop has been in operation since the guild first opened.

Traditional Shop: Fine china, silver, collectables and gifts. Proceeds benefit the Children's Hospital at Stanford.

Allied Arts Restaurant: Run by volunteers and located in the former weaving room, the restaurant has seating in the Court of Cervantes or overlooking the Garden of Delight. Fashion shows and special events are held throughout the year.

PALO ALTO CULTURAL CENTER

1313 Newell Road
Palo Alto
(415) 329-2366

Hours: Tu-Sat 10am-5pm; Thurs 7-9pm;
Sun 1-5pm
Admission: free

Surrounded by landscaped sculpture gardens, the Palo Alto Cultural Center is a peaceful place to view changing exhibits of contemporary and traditional fine art, crafts and designs, and special private and public art collections. Each year more than 75,000 people visit the light and airy center, which is housed in the old Palo Alto city hall, converted into a visual arts center in 1971. Emerging and established artists are showcased, with recent installations by such notables as Kurt Wold, Christopher Brown and Keith Haring. Haring's "The Altar Piece" from his 1994-95 exhibit was purchased by San Francisco's Grace Cathedral and is on display in a small chapel.

One of the most acclaimed shows, *Marriage in Form*, a retrospective of Kay Sekimachi & Bob Stocksdale's works over the 30 years of their marriage, received a National Endowment for the Arts grant and traveled to the Renwick Gallery, Smithsonian Institute and Rhode Island School of Design.

Besides the galleries, the center houses classrooms, studios and performing arts spaces. A community educational program hosts lectures, workshops and forums by artists, critics, collectors and curators.

Shop: Handmade cards, pottery, glassware and jewelry.

Untitled, 1994. By Christopher Brown, Pastel on paper 43.5x40.5".
Photo courtesy of the Palo Alto Cultural Center.

BARBIE DOLL MUSEUM

433 Waverley St.
Palo Alto
(415) 326-5841

Hours: Tu-Fri 1:30-4:30pm;
Sat. 10am-12noon and 1:30-4:30pm
Admission: $4 all ages

Chances are that most little girls have spent at least some part of their childhood playing with Barbie. Created in 1959, this All American doll is the most popular in the world, with more than 150 countries selling the model-like blond and her handsome playmates.

At the Barbie Hall of Fame Doll Studio, the first and only museum dedicated to Barbie's history, you'll find more than 20,000 different Barbie items, from her first car to school books and furniture.

More than a thousand visitors each month tour the museum, which was founded in 1984 by lifetime fan Evelyn Burkhalter to celebrate Barbie's 25th anniversary. The exhibition doubled within two years. Today the glass cases are chockfull of clothes and accessories chronicling fashion and fads over the last 37 years from Barbie in a bikini to mod Barbie in bell bottoms and long, braided hair. Ken, Midge, Skipper and other Barbie

friends and family are on display as well.

Shop: Barbie videos, t-shirts and other mementos.

Barbie doll trivia: Barbie was born on March 9, 1959. Her full name is Barbie Millicent Roberts and she graduated from Willows High School at age 17. She became the first astronaut in 1965 and has since had careers as a doctor, airline pilot, policewoman and teacher.

The Doll Studio.
Photo courtesy of the Barbie Doll Museum.

She loves golf, tennis, yachting and sports cars. Her wardrobe includes handmade inaugural gowns for each presidential administration since she was born.

Palo Alto Junior Museum & Zoo. Photo courtesy of the Palo Alto Junior Museum.

Lucy Evans Bayland Nature Interpretive Center. Photo courtesy of the Palo Alto Junior Museum.

PALO ALTO JUNIOR MUSEUM & ZOO

1451 Middlefield Rd.
Palo Alto
(415) 329-2111
Hours: Tu-Sun 10am-5pm; Sun 1-4pm
Admission: free

See a ferret, horned owl, raccoon or other wild creature up close at this small community zoo, founded in 1955 by local residents. An adjoining museum has changing nature and science exhibits. The recent *Volcanoes* display was built with a scaled-down model which erupted when kids climbed up one side and slid down the other.

Animal demonstrations are given weekends, and throughout the month special talks are held. The popular *Adopt a Critter* program allows children or families to support one of the zoo animals for a year. The funding provides care for all of the animals, as well as support for the zoo's remodeling efforts.

The museum is conveniently located near a park with picnic facilities and playground, a community theater, and art museum.

The Lucy Evans Bayland Interpretive Center, located at 2775 Embarcadero Road in Palo Alto, is a satellite facility of the Junior Museum and Zoo. The 1700 acre preserve is a salt marsh habitat. A spectacular plank walk out onto the marsh lets the visitor experience the marsh ecosystem. Various interpretive programs and displays are house at the center. (415) 329-2506. A nearby pond is a popular picnic and strolling area.

MUSEUM OF AMERICAN HERITAGE

3401 El Camino Real

Palo Alto

(415) 321-1004

Hours: Fri-Sun 11am-4pm

Admission: free

If you like vintage mechanical gadgets you'll love this offbeat museum filled with one man's thirty-year collection of electrical and scientific artifacts dating from the 1800s to early 1900s.

The museum was founded by Palo Alto accountant Frank Livermore, who over the years had acquired assorted typewriters, cameras, radios, vacuum cleaners, phonographs, cash registers, toasters and hair dryers. When the collection outgrew his Menlo Park home, Livermore started a museum in a former BMW agency in Palo Alto. He moved it to its present space in 1995, where it will remain until the restoration of the historic Williams House in Palo Alto is completed in 1997. The new site will include an old-fashioned kitchen with a Wedgewood stove and copper-tub washing machine, as well as a 1920s doctor's office.

The permanent collection of memorabilia rotates. Recent exhibits have focused on cameras, bicycles and miniature trains.

The museum also hosts a lecture series and Traveling Trunk Program, which takes everyday objects to schools to illustrate science principles.

Shop: A small selection of model planes, cars, unusual toys, puzzles and books.

Mabel Mannequin handles the PBX switchboard at the Museum of American Heritage. The switchboard, a 551-A type manufactured by Bell Telephone for Western Electric Co., was built in 1947. Photo courtesy of the Museum of American Heritage .

FILOLI

Canada Rd.

Woodside

(415) 364-2880

Hours: Tu-Thur tours by reservation at 9:30am, 11:30am, 1:30pm; Fri-Sat self-guided tours from 10am-3pm (last admittance 2pm). Closed early November to mid-February. Holiday teas and special events held in December

Admission: $10 adults; $2 children 2-12

Filoli clocktower. Photo courtesy of Filoli.

While you may recognize this lovely Georgian-style mansion as the Carrington estate from the television series *Dynasty*, it was actually built in the early 1900s for William Bourn, a prominent San Franciscan who made his fortune through the Empire Gold Mine and Spring Valley Water Company. The name comes from the first two letters of key words in his credo: *Fight For A Just Cause, Love Your Fellow Man, Live A Good Life.*

The Bourns chose California architect Willis Polk to design the 36,000 square-foot mansion, which has 43 rooms, a Flemish

bond brick exterior, French windows, arched double chimneys and a Spanish tile roof. It is considered one of the finest examples of country house architecture in the nation. Mr. Bourn loved the British Isles and selected the location because of its resemblance to the Lakes of Killarney in Ireland.

Many of the major rooms have 17-foot ceilings. There are seventeen wood-burning fireplaces, including a massive ormolu decorated fireplace in the ballroom and a French escallette marble fireplace in the dining room. The flooring throughout the house is splendid: walnut in a herringbone pattern in the library and oak parquet in a Versailles pattern in the drawing and reception room.

The design of the ballroom was a collaboration between Mrs. Bourn and noted muralist Ernest Peixotto, who painted the murals depicting Muckross House and Abbey and the Lakes of Killarney. Mrs. Bourn chose the French crystal chandeliers and massive French marble fireplace to complement the "water green" color. The floor is quarter-sawn oak in a parquetry design and the ceilings are 21-feet.

Outside is the world-famous 16-acre formal garden surrounded by a brick wall and fences. Walkways circle past an English knot garden, sunken garden and Chartres Cathedral window garden, designed with boxwood hedges between flower beds to represent the lead outlines of the Jesse stained glass window of the famous French cathedral. A rose garden has cutting beds for flowers used in the arrangements in the house.

Architect Arthur Brown, Jr. designed the garage, dominated by a Christopher Wren-inspired tower, and the Italian Renaissance-style Garden House.

In 1937, William Roth of the Matson Shipping Lines bought the estate. His wife Lurline, loved horticulture and continued to enhance the grounds by introducing new shrubs and trees, including hundreds of camellias, rhododendrons, roses and magnolias. The gardens were later named in her honor.

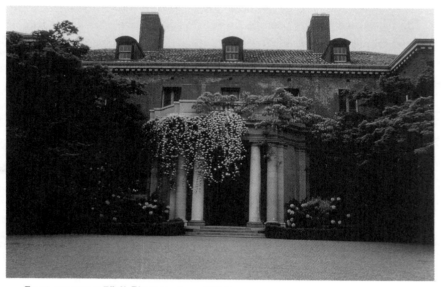

Front entrance at Filoli. Photo courtesy of Filoli

The Roths deeded the estate to the National Trust for Historic Preservation in 1975.

Shop: Lovely garden-related items and accessories.

Cafe: Tea and cookies are served in the Tea Shop, or visit one of the fine restaurants in the nearby village of Woodside.

THE LACE MUSEUM
552 South Murphy Ave.
Sunnyvale
(408) 730-4695

Hours: Tu-Sat 11am-4pm
Donation

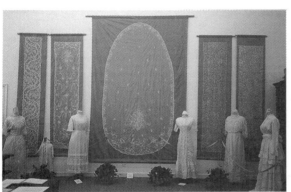

Photo courtesy of the Lace Museum.

The idea for this museum started with a bicentennial celebration for the country's 200th anniversary. Founders Cherie Helm and Gracie Larsen were organizing the event when they discovered each had an interest in lace. Cherie had been collecting lace and thread for thirty years, and Gracie had dreamed of opening a small museum with patterns and laces inherited from an aunt. The dream came true in 1978 when they moved their collection into a small site at the Old Mill in Mountain View. The museum moved to a larger location in Sunnyvale a few years later. Changing displays feature vintage tablecloths, handkerchiefs, bonnets, jackets, dresses and other lace items from the 1800s to the present.

Shop: Lace supplies, books and bobbins.

Classes are offered in Tatting, Needle Lace, Crochet, Parasols, and Bobbin Lace.

TRITON MUSEUM OF ART

1505 Warburton Ave.

Santa Clara

(408) 247-3754

Hours: Tues. 10am-9pm; Wed-Fri 10am-5pm; Sat-Sun 12N-5pm

Admission: free

San Francisco architects Barcelon and Jang took their inspiration from early California missions when designing this award-winning building with its post-modern stucco exterior and pillared entry.

Triton Museum of Art. Photo by Pat Kirk. Courtesy of the Triton Museum of Art.

The open, airy interior is built around a skylit rotunda which acts as an axis for the galleries, work spaces and sculpture garden set on seven acres of rolling lawn.

The museum originally opened in San Jose as the San Jose Museum. Major benefactor Austen Warburton, whose portrait hangs in the lobby, moved the institution to its present site in Santa Clara, changing the name to the Triton Museum, after "Triton," the god of the sea.

There are two main galleries. The Permanent Collection gallery has 19th and 20th century American art and Native American artifacts. The Warburton Gallery features rotating exhibits, with recent shows of Picasso, the Anderson Collection and Chinese and Native American art.

Allow time to tour the property. Besides a magnificent statue of a Morgan horse donated by Robert Morgan, founder of the Triton, there's an 1866 Victorian Jamieson-Brown House which belonged to farmer Samuel I. Jamieson, who came west in 1849 to prospect gold.

Collector's Gallery: Ethnic art and artifacts including decorative gourds, jewelry, soapstone sculptures and Native American baskets.

Exterior of the de Saisset Museum. Photo by Glenn Matsumura. Courtesy of the de Saisset Museum.

de SAISSET MUSEUM

Santa Clara University
500 El Camino Real
Santa Clara
(408) 554-4528
Hours: Tues-Sun 11am-4pm
Admission: free

This art and history museum was founded in 1955 by Isabel de Saisset in memory of her brother Ernest, an artist and former student at Santa Clara University. Situated in a 14,000 square-foot building, the museum showcases rotating exhibits of paintings, prints and sculpture by well-known European and American artists from the 16th century to the present including Goya, Bonnard and Hogarth.

The lower level houses the University's California History Collection, with artifacts from early Indians to the founding of the Mission. On display are Native American fiber baskets, the cornerstone of the 1791 mission church, a 16th-century wooden statue of Mary Magdalene and an array of 19th-century scientific instruments.

In 1989, the museum was bequeathed the Helen Johnson collection of photographs with holdings by such renowned artists as Ansel Adams, Wynn Bullock, Imogen Cunningham

Part of the California History Collection at the de Saisset Museum.
Photo by Glenn Matsumura. Courtesy of the de Saisset Museum.

and Annie Leibovitz. The museum also has the largest public collection of works by 20th-century artist Henrietta Shore, considered one of the great women painters of her time.

Adjacent to the de Saisset is Mission Santa Clara de Asis, the eighth in the chain of 21 missions. Free self-guided walking tours of the mission and university are available at the front desk.

SAN JOSE MUSEUM OF ART

110 South Market Street

San Jose

(408) 294-2787

Hours: Tues.-Sun. 10am-5pm; Thur. 10am-8pm

Admission: $6 adults; $3 seniors, students, youths (6-17); children under six free; free the first Thursday of the month.

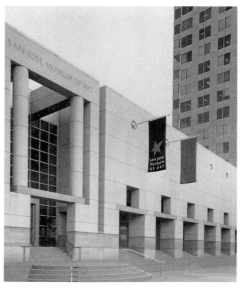

The San Jose Museum of Art. Photo courtesy of the San Jose Museum of Art.

Located in the heart of Silicon Valley, the San Jose Museum of Art is the major art museum in the South Bay devoted to twentieth century art, with an emphasis on post-1980 Bay Area artists. There are two wings: the Historic Wing, designed in 1892 by Willoughby Edbrooke, and the New Wing, a beautiful 45,000-square foot addition designed by Skidmore, Owings & Merrill and opened in 1991.

The museum was founded in 1969 on the site of the Old Pueblo of San Jose, which served as a meeting place and arena for

"Andy Goldsworthy: Breath of Earth"
Installation View, Central Gallery
Shown: Clay Holes, Bracken/Fern Wall Drawing,
Snow Drawings. Photo courtesy of the San Jose Museum of Art.

bullfights and church processions. An elaborate post office was
constructed in 1890 in the Richardsonian Romanesque style,
with a handcarved sandstone facade, ornately embossed copper
interior, solid oak doors with bronze hinges and imported
marble floors. The building, with its landmark clocktower,
eventually became the Main City library and an art gallery
before it was declared an historical landmark and officially
named San Jose Museum of Art.

In 1992, the museum reached an unprecedented agreement with
New York's Whitney Museum of American Art to collaborate
on four long-term exhibitions drawn from the Whitney's

permanent collection of more than 10,000 objects. Exhibitions have included masterworks by artists Georgia O'Keeffe, Andrew Wyeth, Mark Rothko, Andy Warhol, Alexander Calder, and Wayne Thiebaud, among others.

The SJMA permanent collection has sculptures, paintings, prints and drawings by such noted artists as Sam Francis, Richard Diebenkorn, Rupert Garcia, Robert Arneson and Deborah Oropallo.

The museum also presents a diverse schedule of changing exhibitions from contemporary Vietnamese art to the photography in the electronic age. Three chandeliers from a recent show by acclaimed glass artist Dale Chihuly hang in the lobby.

Activities include Monthly Family Sundays, Art Talks and Arts Alive concerts. The Museum Art School was founded 20 years ago and provides ceramics, drawing, painting and other visual arts classes to children and adults.

Shops: Two gift shops. The Skybridge, on the second floor sells a small array of books, videos, jewelry and gift items. The Pavilion at 150 South First Street features a more extensive selection of the same.

Cafe: The Artfull Cup serves espressos and pastries.

Egyptian Museum & Planetarium. Photo courtesy of the Egyptian Museum.

EGYPTIAN MUSEUM & PLANETARIUM

Rosicrucian Park
1342 Naglee Ave. San Jose
(408) 947-3600; Planetarium (408) 947-3636

Admission: $6 adults; $4 seniors and students; $3.50
youths (7-15); children under 7 free
Hours: daily 9am-5pm

The mysteries of ancient Egypt are revealed at this eclectic
museum, housing one of the largest collections of Egyptian
artifacts on the West Coast.

The main building, set in the garden-like Rosicrucian Park, is
inspired by the Temple of Maon at Karnak, complete with
sphinxes, columns and large stone steps. Papyrus-lined paths
lead past walls carved with hieroglyphs, clustered lotus columns,
elaborate fountains and colossal statues of Egyptian gods. The
hippopotamus/crocodile statue in front of the museum repre-
sents prosperity and good health (these creatures would appear
during the rise of the Nile river).

Inside you'll find Egyptian artifacts: predynastic pottery and
glass, bronze tools, funerary boats and animal mummies. There
is a small collection of human mummies including one found
in a 1971 Neiman-Marcus Department Store Christmas catalog.
The Dallas store was offering authentic "His and Hers"

mummies, approximately 2,000 years old and "richly adorned but gratefully vacant." The museum purchased the cases with the help of an anonymous donor. As the store's shippers were

packaging them, they discovered that one of the cases still contained a mummy. Of course, Neiman Marcus offered to dispose of the mummy before delivery, but the curator graciously declined the offer and accepted the "unvacant" coffin, which is now safely on display at the museum.

A self-guided walking tour of the gardens takes visitors past an obelisk, sunken-patio fountain, ram-headed sphinxes, mosaic mural, falcon pond and other monuments. The Moorish-style

Replica Rock Tomb, Egyptian Museum & Planetarium. Photo courtesy of the Egyptian Museum.

Planetarium is one of the first in the country and offers astronomy programs in the Star Theater.

Shop: Museum-quality Egyptian-style jewelry and gifts.

Cafe: Egyptian-theme drinks including Cleopatra's Delight, a latté with honey and almond flavoring, ice cream and snacks.

CHILDREN'S DISCOVERY MUSEUM OF SAN JOSE

180 Woz Way

San Jose

(408) 298-5437

Hours: Tu-Sat 10am-5pm; Sun 12noon-5pm

Admission: $6 adults; $5 seniors; $4 children 2-18

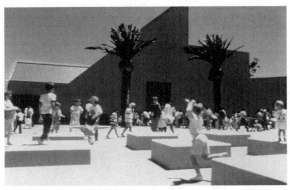

Filled with quirky and innovative hands-on exhibits, this expansive split-level museum is designed to

Photograph courtesy of Children's Discovery Museum of San Jose.

appeal to the "kid" in all of us. You can assume the job of fireman, ambulance driver or go behind the scenes of a recreation post office to learn about the inner workings of the postal service. The newest exhibit, Bubbalogna, lets you explore the fascinating phenomena of bubbles by operating a bubble stretch machine, bubble blower and tower of bubbles. At Artworks II, you can craft a project to take home in an open-studio environment.

Shop: Creative books, toys and games

Cafe: Operated by Hope Rehabilitation Services and serving snack foods and beverages. Picnic tables are located in Guadalupe River Park, surrounding the museum.

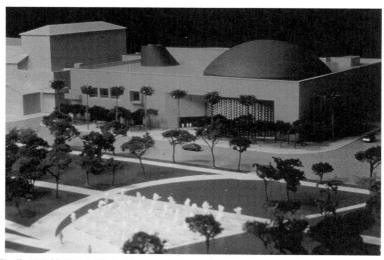
*The Exhibit Hall at the Tech Museum of Innovation.
Photo courtesy of the Tech Museum of Innovation.*

TECH MUSEUM OF INNOVATION

145 W. San Carlos St.

San Jose

(408) 279-7150

Hours: Tu-Sat 10am-5pm; Sun 12noon-5pm; July 1-Sept. 1 Mon-Sat 10am-6pm; Sun 12noon-6pm

Admission: $6 adults; $4 students and seniors; free for children under 6.

At the Tech, you can fly over the surface of Mars, see a nine-foot-square microchip or design your own bike at a computer. Conceived 19 years ago as a science and industry center by a member of the Junior League of Palo Alto, the museum has evolved into one of the most important projects ever built in the South Bay. "Our approach is different from a traditional science museum," says Peter Giles, president and chief executive officer. Rather than scientific principles, the museum features end results.

The Tech allows visitors to explore the technology that has made Silicon Valley famous. There are six areas of concentration: space, microelectronics, biotechnology, robotics, materials and bicycles. One of the most fascinating areas is robotics, where kids can command a robot to answer the phone, make dinner or sketch their portrait. Another workstation lets them design a building and then test its strength against an earthquake. Last year, the Tech and Monterey Bay Aquarium jointly introduced Live Link to Monterey Bay, live undersea video images from

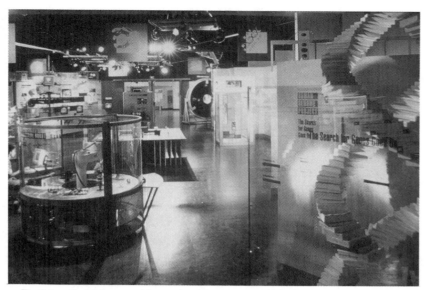

The future Tech Museum of Innovation. Photo courtesy of the Tech Museum of Innovation

deep in Monterey submarine canyon accompanied by audio interpretation.

In November 1998, the Tech will move into a spectacular 112,000 square foot downtown facility designed by Mexican architect Ricardo Legorreta. In addition to four major exhibit theme areas, the new site will have a large screen Omnimax theater, an observation deck, an orientation theater, and more than 250 cutting-edge exhibits. Visitors will be able to see a computer simulation of how their face will age, take a simulated bobsled ride down an icy slope or put themselves into a movie with the latest virtual reality software. There will also be a gallery with images of a heart beating inside a mannequin's chest to show how cardiologists monitor the body.

Cafe: Snacks, sandwiches, salads and desserts

Shop: Silicon Valley souvenirs, educational gifts and gadgets.

AMERICAN MUSEUM OF QUILTS AND TEXTILES

60 S. Market St.

San Jose

(408) 971-0323

Hours: Tu-Sun 10am-4pm; Thur 10am-8pm

Admission: $4 adults; $3 seniors and students; children 12 and under free.

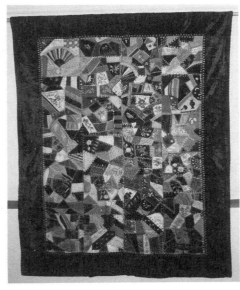

From the permanent collection of the American Museum of Quilts and Textiles.
Photo by Lois V. Johnson. Courtesy of the American Museum of Quilts & Textiles.

Quilts and textiles from the 19th and 20th century are the focus of this museum, founded in 1977 by the Santa Clara Valley Quilt Association and the first museum in the nation devoted to quilts. Exhibits come from the museum's own collection as well as from around the world. Workshops and lectures provide an understanding of quilts as art, historical and cultural documents. The museum also maintains a reference library on the preservation and history of textiles.

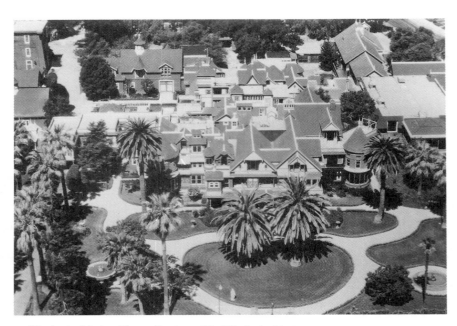

Winchester Mystery House. Courtesy of the Winchester Mystery House.

WINCHESTER MYSTERY HOUSE

525 S. Winchester Blvd.

San Jose

(408) 247-2000

Hours: daily 9am-8pm summer; 9am-4pm early spring; 9am-4:30pm late spring and fall; 9:30am-4pm winter. For the current tour schedule call (408) 247-2101

Admission: $12.95 adults; $9.95 seniors; $6.95 children 6-12; children under 12 are free.

•Allow 2 1/2 hours. Tour includes:
•Guided Mansion Tour: 65 minutes
•Winchester Historical Firearms Musem
•Winchester Antique Products Museum
•Self-guided Victorian Garden Tour.

So many bizarre oddities fill this 160-room Victorian mansion, designed and built by Winchester Rifle heiress Sarah Pardee Winchester, that it has become known as the Winchester Mystery House.

Started in 1884, the project was still under construction thirty-eight years later when Mrs. Winchester died at the age of 82. Though no one has been able to explain her motivations, it is believed that after the premature deaths of her baby daughter and husband a Boston soothsayer convinced Mrs. Winchester that continuous building would appease the spirits of those killed by the Winchester rifle and help her achieve eternal life. She purchased an eight-room farmhouse and kept carpenters working 24 hours a day, building 40 bedrooms, 13 bathrooms,

2,000 doors and 10,000 windows, using her inheritance of $20 million to support the construction.

The mansion is an architectural wonder. Unlike many homes of this period, it had modern heating and sewer systems, three elevators, 47 fireplaces and gas lights that operated by pushing a button. Floors are beautiful hand-inlaid parquet, and chandeliers are gold and silver. Many windows are Tiffany art glass.

Visitors can tour 110 of the rooms and six acres of landscaped gardens. Throughout the grounds are reminders of Mrs. Winchester's preoccupation with the occult and the number thirteen: 13 cement blocks in the Carriage Entrance Hall, 13 blue and amber stones, 13 nooks in her seance room, 13 lights in the chandeliers and 13 windows and doors in the sewing room.

In 1974, the mansion was placed on the National Register of Historic Places and designated a California Registered Historical Landmark.

Historic Firearms Museum

One of the largest Winchester Rifle collections on the West Coast is featured in this museum. On display is B. Tyler Henry's 1860 repeating rifle that Oliver Winchester adapted and improved upon and which came to be called "The Gun That Won the West," for its superior steel mechanism and heavier center fire cartridges. In addition, there is a collection of Limited Edition Winchester Commemorative Rifles including the Theodore Roosevelt and the John Wayne.

Antique Products Museum

A rare collection of antiques manufactured by the Winchester

Products Company can be found here ranging from Winchester cutlery, flashlights, lawn mowers and roller skates to food choppers, electric irons and farm and garden tools. At one time there were 6,300 Winchester stores carrying these products, making it the largest hardware chain store organization in the world.

Garden Tour

The Victorian garden has been beautifully restored to include 14,000 miniature boxwood hedges and large flowering Carolina cherry laurels, among other plants and flowers. Handcrafted European statues of mythological figures include Mother Nature, Cupid, a cherub, a deer, egret and swans.

Shop: The Shoppe has a wide array of gift items and Winchester souvenirs: jewelry, mugs, glassware, as well as books about the Victorian era.

Cafe: Snacks, desserts and beverages.

MC PHERSON CENTER FOR ART AND HISTORY

705 Front St.

Santa Cruz

(408) 454-0697

Hours: Tu-Sun 11am-4pm; Thurs 11am-8pm

Admission: $3 adults; students and children under 12 with adults free.

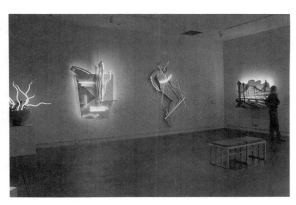

Californeon exhibit. Photo courtesy of the McPherson Center.

Two very different museums are housed under the roof of this modern structure, only a block from the heart of downtown. The History Museum focuses on the history of Santa Cruz County, with exhibits related to the area's development: Indian baskets, the history of Japanese in the area, a photographic journey of the Great Depression, while the Art Museum mounts diverse and innovative installations including one-person shows of internationally recognized artists like Judy Chicago, Christo, David Hockney, Manuel Neri and Wayne Thiebaud.

A lecture series is held concurrently with new exhibits, and on the second and fourth Saturday of the month an interactive art education program for children uses current exhibits as inspiration for their own creativity.

Shop: Books on local history as well as locally made crafts and art. The cookbook from the Garlic Festival is a heavy seller.

Cafe: Cooper Street Cafe has outdoor seating and live jazz on weekends.

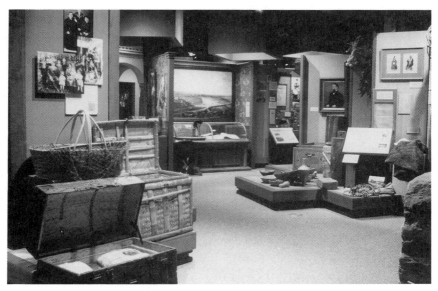

History Gallery SCCHT. McPherson Center 1993.
Photo by Al Lowry. Courtesy of the McPherson Center.

Index

Index

About the Author

Kristine Carber is an awardwinning writer whose work has appeared in Sunset, San Francisco Focus, San Francisco Magazine and Image magazine. A long-time resident of the area, she often writes on art, architecture and design. She has written a Day Trips column for the San Francisco Examiner since 1992, and often contributes to the Sunday

Photo by Russ Fischella, SF.

magazine. She received her degree in history from UCLA, with post-graduate work at UC-Berkeley. An avid museum and gallery-goer, she has led tours at many of the institutions mentioned in the book.